IMAGES
of Aviation

MORRISTOWN
MUNICIPAL AIRPORT

ON THE COVER: FIRST CONTROL TOWER. This was the first control tower at Teterboro Airport. It remained at Teterboro until 1948, when the Federal Aviation Association (FAA) built a permanent control tower. This one was sold to Morristown Airport for a reported $17,000. It was dismantled and trucked to Morristown and reassembled. It remained there until 1961, when the current control tower was opened. The airplane is a Beech 18. (Jim Geiger.)

IMAGES
of Aviation

MORRISTOWN
MUNICIPAL AIRPORT

Henry M. Holden
and Darren S. Large

ARCADIA
PUBLISHING

Published by Arcadia Publishing
Charleston SC, Chicago IL, Portsmouth NH, San Francisco CA

Printed in the United States of America

Library of Congress Control Number: 2010923681

For all general information contact Arcadia Publishing at:
Telephone 843-853-2070
Fax 843-853-0044
E-mail sales@arcadiapublishing.com
For customer service and orders:
Toll-Free 1-888-313-2665

Visit us on the Internet at www.arcadiapublishing.com

CONTENTS

ACKNOWLEDGMENTS

There are many people who have been an integral part of the development of this book, and without their help it would have never been possible. To Henry Holden, thank you for partnering with me on this project; I have enjoyed working with you during the past few months. To Erin Rocha, our editor, thank you for working with us. Thank you William Barkhauer and Robert Bogan, who provided historical information and allowed me the opportunity to work on the book. Thanks also to Scott McMahon, Felicia Coppola, and the rest of my DM Airports, Ltd., family for their encouragement and support. Thanks go out to Jim Gieger, Carl Laskiewicz, and Robert Vanderhoof, who provided multiple pictures and historical information. Leslie Large also worked with me, compiling historical articles. My family, friends, and parents, Kevin and Laura Large, and Cathy and Roy Moseley provided more than I could ever thank them for. My wife, Jessica, my best friend; I could not do it without you.

—Darren S. Large

I would like to acknowledge Darren Large for joining me in this endeavor. This was truly a team effort, with the two of us bringing just the right skills and attitudes to the table. It was a pleasure to work with such a professional. We both had this goal on our "Bucket List," and now we will move on the next listing.

Many of the photographs are Darren's original work, but a big thank-you must also go the New Jersey Aviation Hall of Fame and Museum (NJAHOF) and its executive director, Shea Oakley, for his cooperation and access to the photograph archives. I also want to thank my wife and best friend, Nancy, for always giving me the space I needed to write; I love you.

—Henry M. Holden

INTRODUCTION

On July 8, 1929, the *Newark Star Ledger* announced the opening of the Morristown Airport on the old Niese place on Bernardsville Road. The article stated the airport would be the home of the Country Aviation Club, under the supervision of Clarence Chamberlin, the second man to fly the Atlantic Ocean and the first to take along a passenger.

In the early 1930s, a decision was made to move the airport to a 280-acre tract of land occupied by the Normandy Water Works on the Columbia Meadowlands.

Morristown's geological condition dates back to the glacial era. As the glaciers receded, they left behind the great Lake Passaic, which, according to geologists, was approximately 40 feet above the current Columbia Turnpike and Park Avenue that border the airport. The lake may have extended as far as the city of Summit. Unlike the eastern portion of the state, near the Newark and Teterboro Airports that are on meadowlands just a few feet above sea level, Morristown Airport sat on the base of the great Lake Passaic. In prehistoric days, this body of water covered the Columbia Meadows. Just as today airplanes can be seen taking off from Morristown Airport, it is possible, according to reports of the state geological survey, to visualize great icebergs breaking off and bobbing around in the great Lake Passaic of prehistoric times.

A U.S. Army Air Corps pilot, Lieutenant Draper, was in charge of the airport and planned to hold two parachute jumps a day to encourage publicity and draw visitors. However, the Great Depression was at one of its deepest points, and not much activity took place on the airfield for the first few years of its existence. Then, in 1934, the federal government provided funds for airport improvements under the Works Project Administration (WPA). A large part of the work had to be done by machinery, so the government leased some of the equipment from Morristown, and the WPA funding provided wages for the workers.

Morristown was just one of several airports across the country designated as a federal relief project. As the federal government shifted money around, some of the workers were laid off, and others worked, albeit temporarily, without pay. The money continued to flow into the Morristown Airport project, and hundreds of men were at work clearing and leveling the land.

Much of the activity was in preparation for an expected zeppelin base, fueled by the popular commercial German dirigible traffic between Europe and America. On October 7, 1936, the German zeppelin *Hindenburg* flew over the Columbia Meadows but did not land. Many speculated that Morristown would be the future eastern American terminal for the transoceanic flights of the Graf Zeppelin Company. The airship had taken off from Lakehurst, New Jersey, with 73 influential civic and business leaders in the United States with joint objectives. They wanted to interest the business community and put the giant airship on display over New Jersey to gain community support. The crash of the *Hindenburg* the following year ended all discussions of a zeppelin base. Although the idea of a zeppelin base was dead, Clyde Potts, the mayor of Morristown, continued to push for the development of an airport on the site.

Weather readings and survey work performed for the *Hindenburg* helped push the area to be developed by the U.S. Army Corps of Engineers. In the early 1940s, the corps had the wind data and knew how to lay out the airport from earlier fact-finding. The Works Progress Administration

project attempted to drain off the land. That job went under, and work did not resume until the World War II broke out, and the government supplemented the construction cost through a grant program to build new army air bases.

The U.S. Army Air Corps of Engineers continued construction of the airport in 1941. On January 21, 1942, the president of the Morristown Airport Corporation, Edward K. Mills Jr., submitted a detailed proposal for the award of a contract to conduct an army primary flight-training center at the airport. For more than two years, the airport had been conducting a civilian pilot training program, one that anticipated the coming war and the need for pilots.

The army's response to Mills's letter was that under the present policy, "such factors as weather, climate, and terrain, suitable for elementary flying operations precluded the establishment of such schools as far north as New Jersey." This policy would be revisited as the United States went on the war offensive. During World War II, the airport also served as a test site and training facility for Bell Telephone Laboratories.

Near the end of World War II, the army returned to the airport with $1.5 million worth of instruments. The army needed to use the airport as a depot for the 200 to 300 surplus aircraft that would be sold to the airlines and civilian companies. By 1947, growth was on the horizon. Morristown put $60,000 into the purchase and installation of hangars.

Morristown Municipal Airport's greatest challenge came after the war, when the area began to change from the mostly rural open country of when the airport was built to a heavily developed residential area that continues to become ever more densely populated, hemming the airport in on every side. The change brought neighbors whose demands for peace and quiet had to be balanced against the airport's clients' needs and its own need to grow to survive. Morristown Municipal Airport would challenge itself to preserve and prohibit the development of further land around it to provide a buffer for its neighbors in the midst of the encroaching sprawl.

Morristown Municipal Airport began to grow, and it played host to many of the aviation firms in Morris County. At the time, these firms made Morris County a leader in the research and development of aviation technology. With the settlement of thousands of employees, satellite industries and companies began to settle in and around Morristown.

The airport has been under assault by its opponents for decades. With Morristown as the county seat for Morris County, there has been a continuous population growth for decades. Zoning suits were thought to be the most effective way of limiting the airport's expansion and the associated noise. In a 1956 suit against Morristown by Hanover Township, the township argued that the airport "is a business pure and simple" and "entitled to no greater sanctity than a private corporation."

Morristown responded: "the airport served an essential governmental function serving the public need and by virtue of its nature is immune from the zoning power of Hanover Township." A unanimous ruling by the New Jersey Supreme Court held that Hanover Township's zoning ordinance was inapplicable to the airport.

The ruling, no doubt, took into account the increasing revenues brought in by the airport. Revenues had increased from $60,384 in 1954, to $62,107 a year later. In 1956, the airport held its second Air Fair, with estimates of up to 10,000 people and 1,300 vehicles attending. A series of jet fighters and a navy blimp flew over the airport. Smaller static displays of airplanes and equipment adorned the airport grounds.

By July 1966, Morristown Municipal Airport was called the "VIP Stop." Ranking 98th in the country in the number of airport movements—i.e. landings and takeoffs—it was classed with the glamour airports such as San Juan International, Las Vegas, and West Palm Beach. During a 10-year period, movements had increased from less than 75,000 to 143,129.

By the end of the decade, the lines had been distinctly drawn between proponents and opponents of the airport. Opponents complained of noise and safety issues, and were not in favor of expansion. They suggested relocating the existing runways to protect the wetlands, building a new airport farther north in the less-developed Bergen and Sussex Counties, and developing a high-speed rail system that would eliminate the need for air taxi services.

In July 1969, Hanover Township, Morristown, Florham Park, and six members of the Citizens for a Smaller Morristown Airport group filed a lawsuit jointly to block the expansion of the runway and the facilities to accommodate medium and short-range jets. A judge ultimately ruled in favor of the airport, but the expansion issue continued for years to come. Proponents argued that service for corporate jets and charter flights is better suited and faster out of Morristown than Newark or Teterboro, which are farther east.

With the arrival of the 1970s and the jet age in full flight, a pattern was now set in the ongoing progress of Morristown Municipal Airport. As the economy grew and demands for additional services from corporate and private clients increased, so too did noise and air-traffic complaints, as neighboring residents and towns continued their pressure to restrict growth at the airport. Each announcement of the airport's request for additional maintenance, services, and/or facility improvement was greeted by uproars of protest and threats of lawsuits. Morristown Municipal Airport would learn to ask for all it could get and settle for what it needed, if possible.

By the early 1970s, work was underway to extend the major runway. Engineers were dredging a swampy area and moving more than 1.7-million tons of mud, sand, and earth to prepare for the runway, installing a new instrument landing system (ILS) and other improvements related to safety.

Air shows continued sporadically at the airport until June 1983. On June 12, a pilot flying a single-engine Thorpe T-18 Tiger was killed when his airplane, classified as a FAA-approved experimental machine, disintegrated in flight about 200 feet over the runway and in front of an estimated 30,000 spectators. The crash was later ruled pilot error, because the pilot exceeded the 200–miles per hour speed limit for the homebuilt aircraft. The accident and other logistical issues ended the possibility for any further air shows.

With the airport's continual growth and maintenance expenses, the question on the minds of the people of Morristown was if the airport would continue to pay for itself or if the taxpayers would end up footing the bill. Initially the airport began earning a small profit, but by 1960, its managers expected the airport to earn a profit of at least $70,000. However, this trend did not continue, and in 1982, Morristown leased the management of the airport to DM Airports, Ltd.

By 2002, there were several hundred aircraft based at Morristown Municipal Airport, including jets, helicopters, turboprops, and others. It became the second busiest in the state, because Teterboro was shut down during the weeks after the September 11, 2001, attacks. Today it is the third busiest airport in New Jersey, surpassed only by Newark-Liberty International Airport and Teterboro. During the last 35 years, the number of flights (arriving and departing) has averaged just over 228,000 per year. The lowest total in 35 years was in 1972 (181,936 flights), and the highest total was in 1980 (282,463). In 2000, it had 271,074 flights.

Morristown Municipal Airport is classified as a General Aviation Reliever (GAR) airport. GAR airports are designated by the FAA to relieve congestion at commercial service airports (usually around a major urban area) and to provide general aviation access to the overall community.

As a GAR airport, Morristown accepts private, corporate, air taxi, air ambulance, training, or military aircraft. The majority of New Jersey's business fleet is located at Teterboro and Morristown airports. Teterboro is widely regarded as a leading corporate airport, ranking sixth nationwide in the number of general aviation operations, while Morristown ranks 11th in general aviation operations. Morristown Municipal Airport houses 12 corporate hangars, 11 individual hangars, 3 flight schools, 1 aircraft maintenance facility, and a full-service fixed base operation (FBO). In 1995, there were 416 aircraft based at MMU. This dropped to 325 in 2000 and 292 in 2006.

In addition to being a major transportation asset, Morristown Municipal Airport is also a major economic asset to Morris County. It supplies an estimated $187 million to the community through total spending/output. Thirty-one companies base 59 aircraft at the airport. Several of these are Fortune 500 companies with headquarters based in Morris County.

The airports in Morris County do not have any large-scale airfreight movement capabilities, although smaller-scale goods, special shipments of various types—i.e. large sums of money, prisoners, military related items, cancelled checks, lab samples, and packages—move through Morristown

Municipal Airport via air courier flights. The closest major airfreight facility is Newark-Liberty International Airport, located in Essex County.

Physical constraints, such as the presence of wetlands and permanently preserved open space, eliminate the potential for future runway expansion; however, Morristown Municipal Airport anticipates adding or replacing hangars and ancillary facilities to make more efficient use of the existing resources and to improve safety.

Today Morristown Municipal Airport covers 638 acres, with 18 acres containing hangars and other buildings, an unspecified number of acres for runways and taxiways, and the remaining balance consisting of open space. It serves private and corporate aircraft in Morristown and Morris County. It is owned by the Town of Morristown and is operated under a 99-year lease by DM Airports, Ltd., an arrangement that began in 1982. The airport is located in Whippany, Hanover Township, 3 miles east of the central business district of Morristown. The airport has two asphalt-grooved runways: runway 5-23 is 5,999 by 150 feet, and runway 13-31 is 3,998 by 150 feet. The airport is at an elevation of 187 feet.

One

THE EARLY YEARS
1930–1960

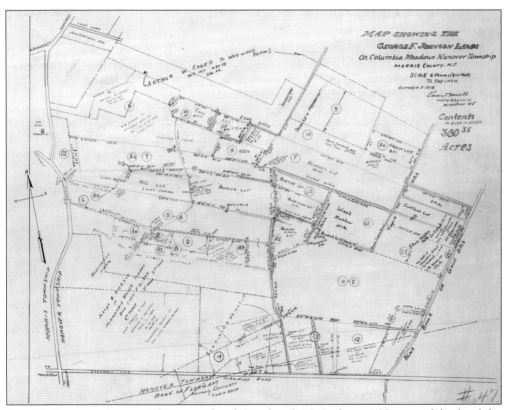

JOHN F. JOHNSON LANDS. This map, dated October 5, 1918, shows 365 acres of deeds of the property that would later become Morristown Airport. The drainage ditches shown on this map were used by the farmers. The land was marshy, but there were orchards and other farming areas on it. On the right is Black Brook, also known as the "Great Ditch." (Morristown Municipal Airport [MMU].)

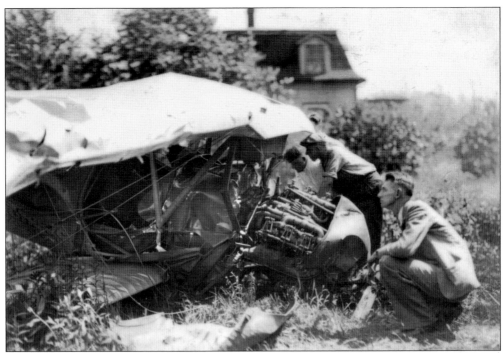

MAIL PLANE ACCIDENT. One of the first experiences Morristown residents had with aviation occurred on September 1, 1920, when Max Miller, a pilot, and Gustave Rierson, a mechanic, crashed their mail plane in Morristown. The airplane was flying low with the engine backfiring badly just before the accident, in which the aviators were fatally injured. (NJAHOF.)

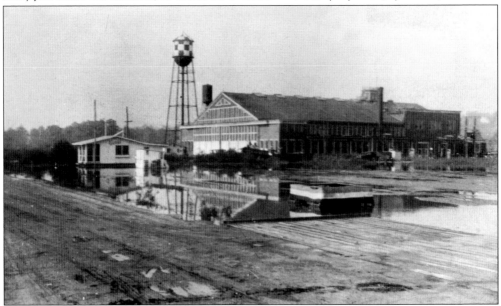

FOKKER FACTORY. Aircraft-builder Anthony Fokker came to New Jersey and settled in Teterboro, approximately 27 miles to the east or Morristown. His activities and record-setting airplanes grabbed all the headlines, leaving airport development west of Teterboro stalled for a decade. (NJAHOF.)

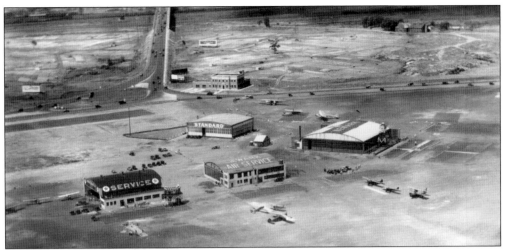

NEWARK AIRPORT. In the mid-1930s, when some in Morristown were beginning to see the potential for aviation in their neighborhood, Newark Airport, approximately 15 miles to the east, was a growing facility. Faced with similar construction challenges that the meadowlands presented to Morristown, Newark filled in and raised the land to make its runways. (NJAHOF.)

MORRISTOWN LOOKING EAST, C. 1930. In the lower center is Morristown High School, and in the upper right, the dense clump of trees is the famous landmark Morristown Green. Moving left in the upper center (northeast) is Morris Plains. The top area is the end of Columbia Turnpike, out by the Ford Mansion. The photograph just misses the airport property. (NJAHOF.)

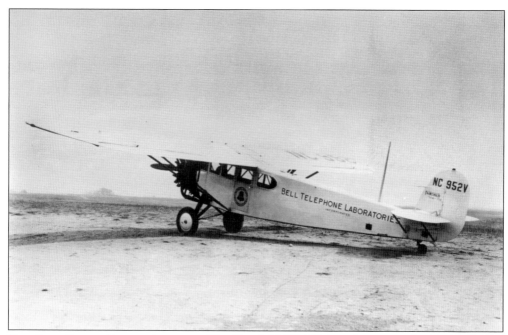

BELL LABS SINGLE-ENGINE AIRPLANE. The Fairchild FC-2W, later known as the Model 71, was built in the United States between 1928 and 1930. Bell Labs was heavily involved in early ground-to-air and air-to-air radio communications in Whippany, the town adjacent to the airport site. Note the large vertical antenna in front of the tail. (NJAHOF.)

CLARENCE CHAMBERLIN. On July 8, 1929, a Morristown newspaper announced the opening of the Morristown Airport on the old Niese place on Bernardsville Road. The article stated the airport would be the home of the Country Aviation Club and under the supervision of Clarence Chamberlin, the second man to fly the Atlantic Ocean and the first to take along a passenger. (NJAHOF.)

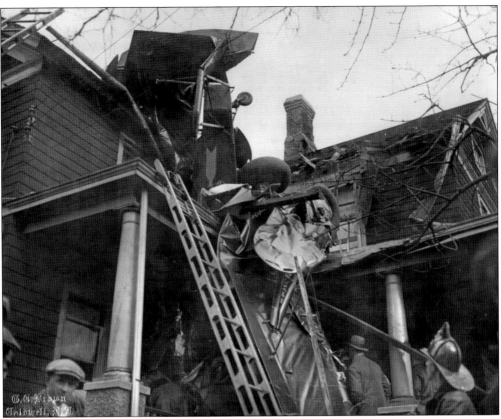

Rooftop Landing. One of the objections raised in 1936 against the airport was that it would lower property values in Morris Township surrounding the airport. On the contrary, over the years the records have shown that residential and industrial properties have increased in value. The more industry drawn to the area, the more property values increased. (NJAHOF.)

Hindenburg over Manhattan. On October 8, 1936, the *Hindenburg* appeared over Manhattan and flew west to the future site of Morristown Airport, making weather recordings and other tests. Morristown buzzed with excitement, and while the huge zeppelin glided around the town everyone was able to claim that the *Hindenburg* "went right over my house." Its subsequent crash deflated any hopes for a blimp base. (NJAHOF.)

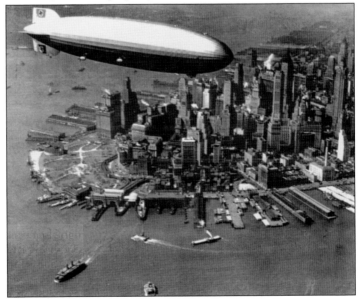

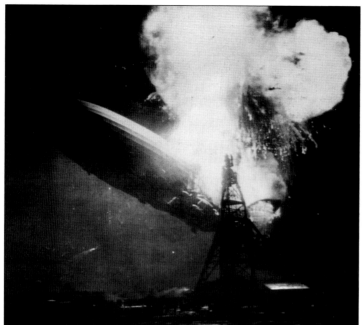

HINDENBURG BURNING AT LAKEHURST NAVAL AIR STATION. On May 6, 1937, the *Hindenburg* arrived hours behind schedule at Lakehurst. Buffeted by winds and rain, the craft hovered in the area for about an hour, during which lightning storms were recorded. Soon after the mooring lines were set, eyewitnesses reported a blue glow on top of the *Hindenburg,* followed by a flame. Flames quickly engulfed the craft, causing it to crash and kill 36 people. (NJAHOF.)

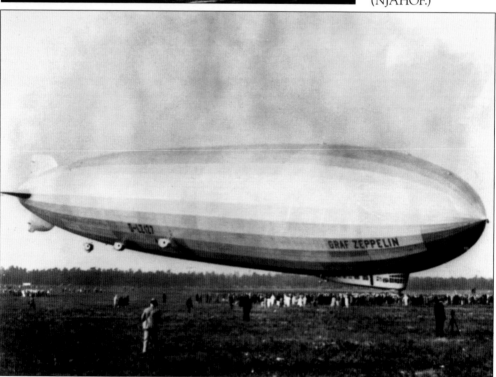

GRAF ZEPPELIN ON ITS FIRST INTERCONTINENTAL TRIP. The *Graf Zeppelin* left Friedrichshafen, Germany, on October 11, 1928, and arrived in the United States at Naval Air Station (NAS) Lakehurst, New Jersey. After the *Hindenburg* disaster in 1937, public faith in the safety of dirigibles was shattered, and flying passengers in hydrogen-filled vessels became untenable. *Graf Zeppelin* was retired one month after the disaster and was turned into a museum. (NJAHOF.)

CHARLES "CASEY" JONES AND GILL ROBB WILSON. Wilson (left) is presenting an award to Jones, a World War I pilot and founder of the Casey Jones School of Aeronautics in Newark Airport. Wilson was one of the earliest proponents of building an airport at Morristown. He prompted the board of aldermen to solicit federal funds for buying adjacent land for the airport's infrastructure. (NJAHOF.)

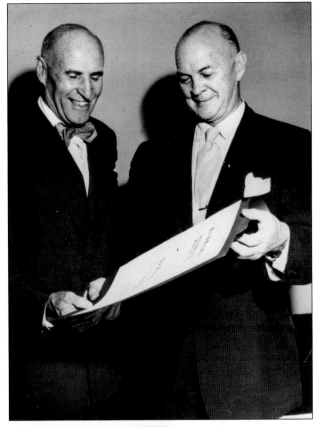

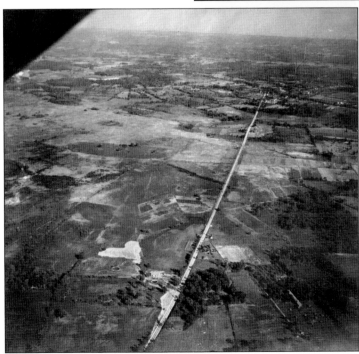

COLUMBIA PARKWAY, LOOKING EAST, c. 1936. This is the original Columbia Meadows before the airport was built. Columbia Meadows is part of the former glacier Lake Passaic that developed after the ice age. In this photograph, Columbia Turnpike runs straight out from the middle of the picture, and Florham Park is forming around the end of the parkway. In the lower center left side of the road are water holding tanks belonging to the Normandy Water Works. (NJAHOF.)

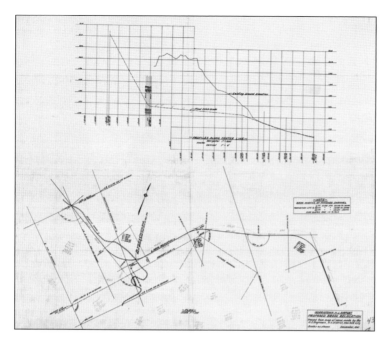

BROOK RELOCATION. This December 1941 drawing shows the proposed brook diversion away from the northwest-southeast runway, the future 5-23 runway. Even before World War II, plans were being made to build an airport in the Columbia Meadows. Just to the left of the Wilson Line is a proposed runway that would show up on future drawings but would never materialize. (MMU.)

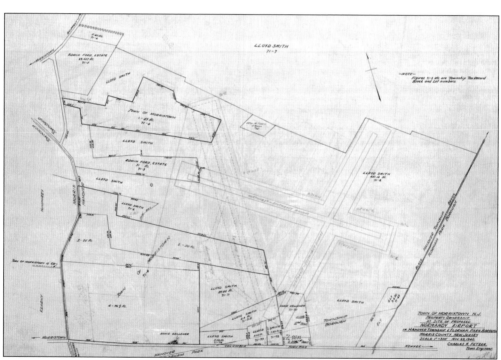

NORMANDY AIRPORT. This is the first appearance of a map illustrating the property ownership of Morristown. Dated November 23, 1940, it assigned the name Normandy Airport to the land that would evolve into Morristown Airport. The bottom center shows Columbia Turnpike and the Hanover and Florham Park boundary lines. The town of Morristown to the left is not within the future airport boundaries. (MMU.)

RUNWAY CUT, C. 1934. This photograph shows the initial cut in the land to create a level runway. In 1931, the Morristown Water Department purchased the Normandy and Whippany Water Company for approximately $212,000. The purchase included more than 200 acres in the Columbia Meadows. Morristown received federal aid during the Depression to build a new airport. The Works Project Administration (WPA) started the construction; but the work stalled until World War II. (New Jersey State Archives.)

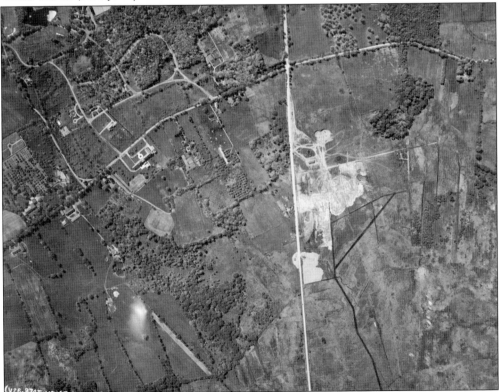

LOOKING WEST. The Columbia Turnpike is the sharp white vertical line, and Park Avenue intersects it at the top of the photograph. Most of the land appears to be orchards or undisturbed. The area on the right side of the Columbia Turnpike appears to be the initial ground breaking for the WPA construction of the airport. Just above the construction site is the Normandy and Whippany Water Company, with its two holding tanks. (New Jersey State Archives.)

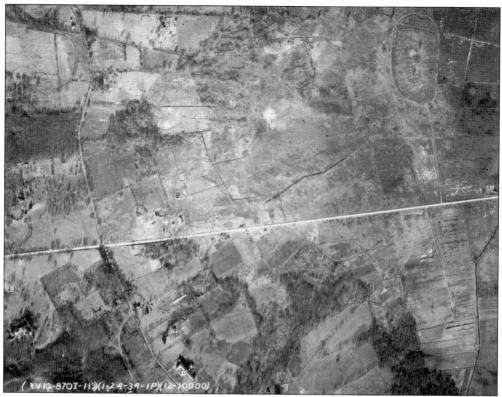

LOOKING NORTH. This photograph, dated January 24, 1934, shows the Columbia Turnpike as a horizontal line. The intersecting road to the left is Park Avenue. To the right of Park Avenue is the Normandy and Whippany Water Company. Take note of the drainage ditches. Not easily seen in this photograph is a collection of vehicles parked across from the Normandy and Whippany Water Company; presumably they belonged to the construction company or the workers. (New Jersey State Archives.)

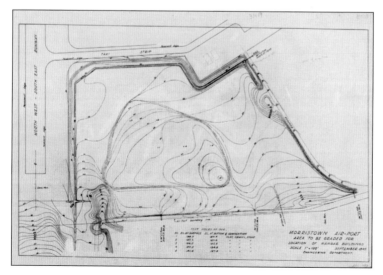

GRADING MAP. This map, dated September 1945, shows the area to be graded for the location of airport buildings and hangars. It is clear from the records found in Morristown's record archives that the town planned a private airport, even before the U.S. Army had returned its land. (MMU.)

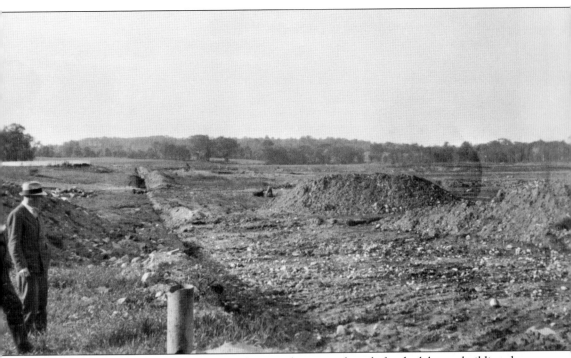

STUDYING THE LANDSCAPE, C. 1934. Weather was the major obstacle for the laborers building the runways. A period of unusual cold and snow almost shut the WPA project down. The warming that followed turned the ground into the marshland it actually was. Wildlife, the breeds that produced fear and loathing in most people, became a common occurrence as the work progressed. "Snakes, snakes, and snakes!" read one newspaper article at the time. (New Jersey State Archives.)

EARLY DEVELOPMENT. This aerial photograph is looking directly down runway 12-30 at Morristown airport. The area at the bottom of the picture is Ford Hill in Whippany. The Columbia Turnpike is on the right side of the picture. New York City is on the far upper left corner on the horizon. (NJAHOF.)

SIXTY YEARS OF DEVELOPMENT. This photograph, taken in 2005 from the same relative position but at a slightly higher altitude, is looking east and down on runway 13-31. New York City is on the horizon. More than 70 years between photographs show vast development of the airport and the surrounding area. The vacant area between the runway and the Columbia Turnpike is now occupied by airport hangars and buildings. (Carl Laskiewicz.)

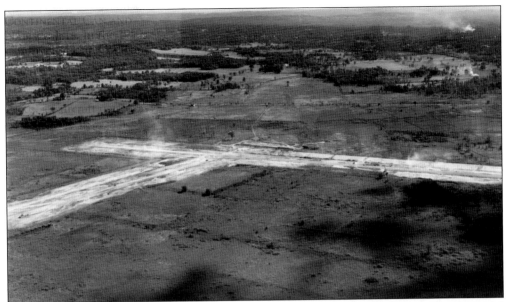

LOOKING SOUTH. Looking south, this early photograph of the airport site appears to be the initial carving out of what is now runway 13-31, crossing from left to right, and 5-23 at lower left. The horizontal line across the middle of the photograph is the future Columbia Turnpike. The original numbering of the runways was 12-30 and 4-22. (NJAHOF.)

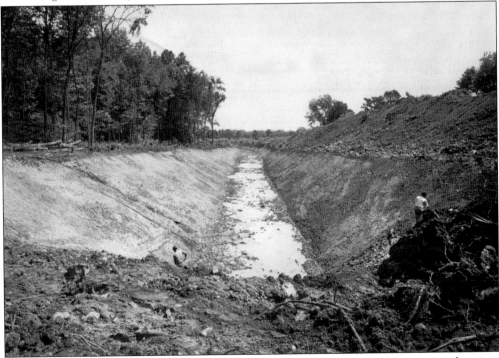

AIRPORT DEVELOPMENT. This photograph, dated August 4, 1941, shows two engineers working in a ditch created to divert a brook. The airport sits over an aquifer, which recharges the groundwater, a source of drinking water for the people in the adjacent townships. In 1941, it was unknown that development of wetlands could prevent the recharging of the aquifer. (MMU.)

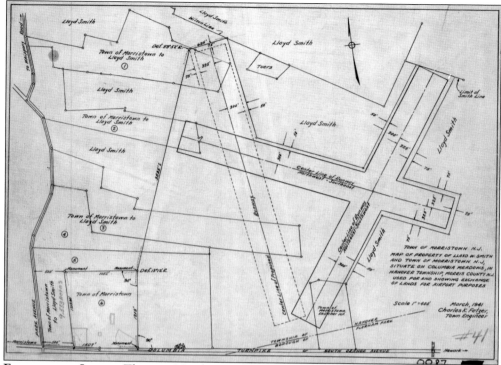

EXCHANGE OF LANDS. This is a March 1941 map of the property of Lloyd W. Smith and the town of Morristown. This map shows the exchange of lands for airport purposes. That same year, Morristown set aside $11,350 for the acquisition of land for the airport. A year earlier, the Civil Aeronautics Administration (CAA) allocated $383,000 to build the airport. Note the third runway (almost vertical line) that was planned but was never built. (MMU.)

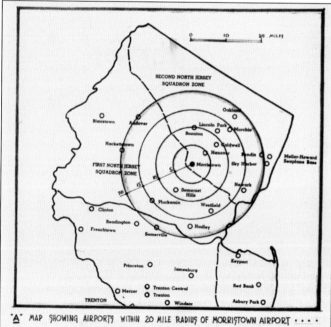

"A" MAP SHOWING AIRPORTS WITHIN 20 MILE RADIUS OF MORRISTOWN AIRPORT · · · ·

AIRPORTS WITHIN 20 MILES OF MORRISTOWN. On January 21, 1942, the president of the Morristown Airport Corporation, Edward K. Mills Jr., submitted a detailed proposal, including this map, for the award of a contract to conduct army primary flight training center at the airport. For more than two years, the airport had been conducting a civilian pilot training program, anticipating the coming war and need for pilots. (From the collections of North Jersey History Center/The Morristown and Morris Township Library.)

TRANSPORTATION FACILITIES
SERVING MORRISTOWN,
c. 1942. This map was part
of Mills's proposal to the
army. The army's response
to his letter was that under
the present policy, "such
factors as weather, climate,
and terrain, suitable for
elementary flying operations
precluded the establishment
of such schools as far north
as New Jersey." (From
the collections of North
Jersey History Center/The
Morristown and Morris
Township Library.)

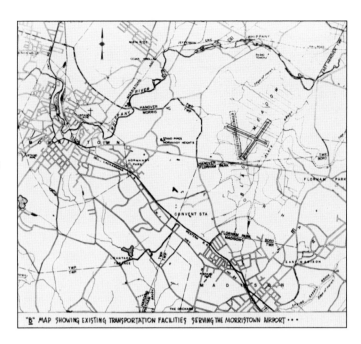

"B" MAP SHOWING EXISTING TRANSPORTATION FACILITIES SERVING THE MORRISTOWN AIRPORT • • •

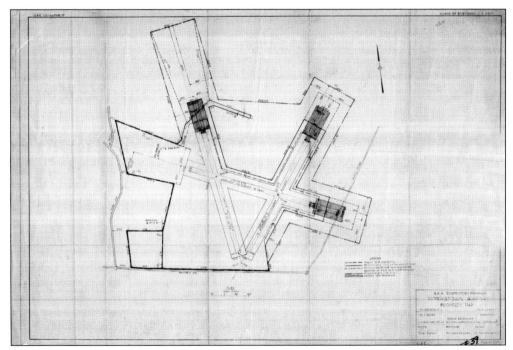

CIVIL AERONAUTICS ADMINISTRATION CONSTRUCTION PROGRAM MAP. From the earliest days of
the planning of Morristown Airport, a third north-south runway (left) had been envisioned. This
September 22, 1942, map was created during the period the army was in charge of the airport. The
dark, shaded areas at the ends of the runways illustrate proposed future extensions. (MMU.)

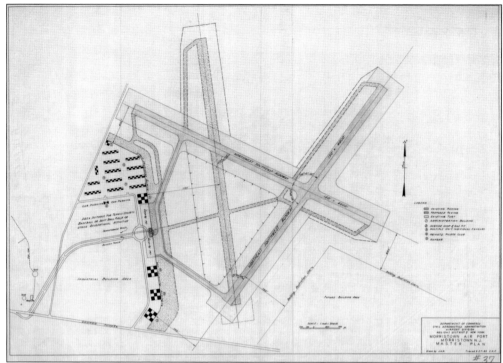

Morristown Municipal Airport Master Plan. Dated June 27, 1945, this was one of the first master plan drawings submitted to the CAA, now the Federal Aviation Administration (FAA). The FAA requires master plans to be submitted for airports to receive federal funding. The master plan drawing shows anticipated development on an airport during a 20-year period. (MMU.)

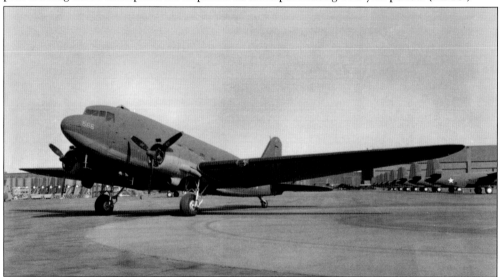

Surplus C-47. Near the end of World War II, the army turned over an airport now worth $1.5 million to Morristown. The army needed to use the airport as a depot for the 200 to 300 surplus aircraft, such as this C-47, which would be sold to airlines and civilian companies. By 1947, the airport was becoming established, and growth was on the horizon. Morristown put $60,000 into the purchase and installation of hangars. (NJAHOF.)

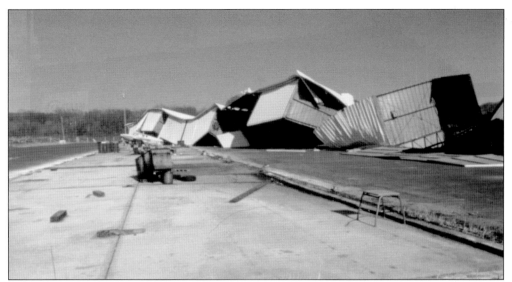

HANGAR COLLAPSE. A June 7, 1948, letter to the Morristown aldermen said, "The building owned by the Morristown Airport Corporation was destroyed by wind. Three airplanes owned by the corporation received varying degrees of damage." The letter reported that nine other airplanes that were privately owned were either damaged by the wind or pulled from the tie-down area and tossed about the field. (MMU.)

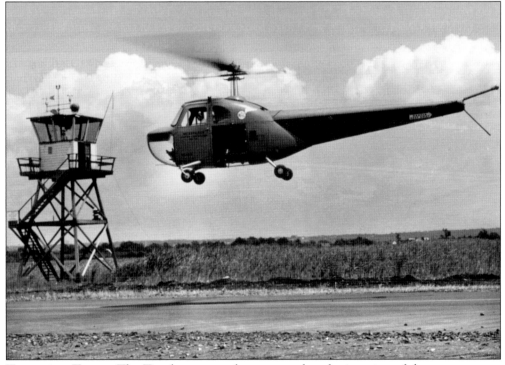

TETERBORO TOWER. The Teterboro control tower stood at the junction of the two runways, mounted on a wooden framework. When Teterboro opened its first permanent control tower in 1948, this tower was sold to Morristown Municipal Airport. The Bell Model 47B approaching the tower was the first commercial evolution of Bell's pioneering Model 30. (NJAHOF.)

TOWER RELOCATED. Morristown Municipal Airport bought the former Teterboro tower in 1948 for $17,000. It was dismantled and trucked 27 miles to Morristown. While it provided some shelter for its controllers, it was cold in the winter and always drafty. It lasted until a new permanent tower was built in 1961. (Jim Gieger.)

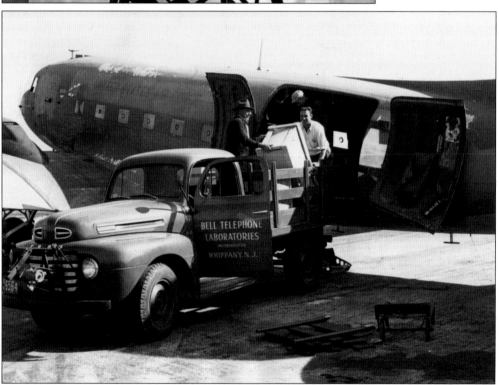

BELL TELEPHONE LABORATORIES. This 1950s photograph shows a former U.S. Air Force C-47's cargo being off-loaded at Morristown Municipal Airport onto a Bell Telephone Laboratories truck. Their Whippany facility contributed a great deal to the development of radar during World War II. During the cold war, the company developed guidance systems and communications satellites. (Jim Gieger.)

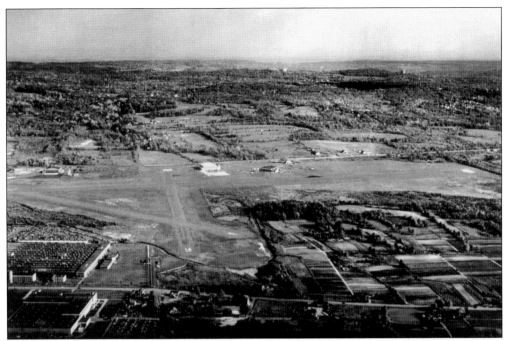

CALDWELL AIRPORT, 1960s. Another possible pressure for growth came when MMU airport manager Robert McGovern was advised that nearby Caldwell-Wright Airport (now Essex County) might close in the late 1960s. He commented that, while his airport would be able to handle the additional traffic from Caldwell, he would prefer Caldwell to remain open, citing "New Jersey did not have enough airports as it is." He also stressed that Morristown Municipal Airport took pride in what McGovern called "orderly" growth. (NJAHOF.)

HADLEY FIELD. This field, which was approximately 35 miles southeast of Morristown Airport, was opened in 1925 and was one of the first airmail airports in the United States. The airport mostly catered to General Aviation and did not develop the large corporate infrastructure that Morristown had. This led to its closure in 1968. (NJAHOF.)

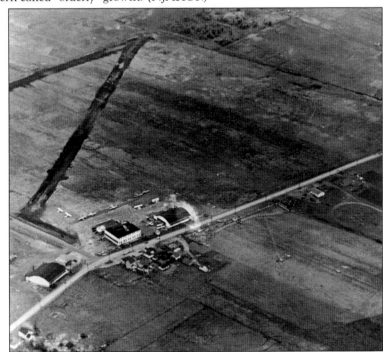

CONTINENTAL CAN HANGAR. In 1951, Continental Can Company became the first corporation to build a hangar at Morristown. Because of the steel shortage, wooden trusses were used for the framework to support the roof. This war-surplus B-24 Liberator became one of Continental Can Company's corporate aircraft. This aircraft originally served in the China, Burma, and India Theater as a cargo aircraft and had the designation C-87. It is still flying today in air shows as Diamond Lil. (MMU.)

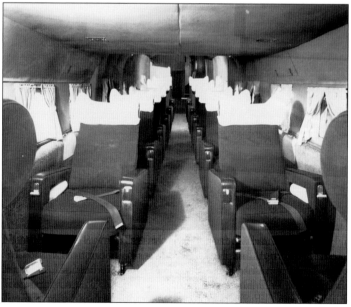

INTERIOR OF CONTINENTAL CAN CORPORATE AIRCRAFT. The interior of this executive aircraft was surprisingly posh for a World War II bomber. After the war there were so many surplus aircraft that the Reconstruction Finance Corporation sold many of them for pennies on the dollar. There was an air-travel boom, and executives thought it advantageous to have an airplane ready on their schedule rather than battle lines in the large airports. (Darren Large.)

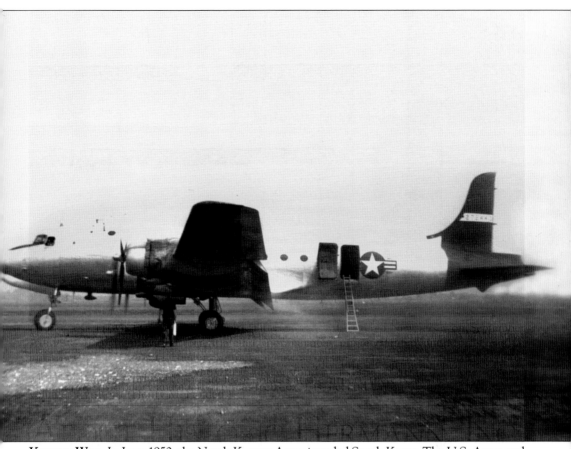

KOREAN WAR. In June 1950, the North Korean Army invaded South Korea. The U.S. Army and Marines, who responded to the aggression, discovered that their bazookas could not destroy the Russian-built T-34 tanks. The nearby Picatinny Arsenal ramped up production of a new anti-tank shell and trucked them to Morristown, where air force cargo airplanes flew them west to Korea. (NJAHOF.)

MORRISTOWN AIRPORT, C. 1950. The first major development at the airport following the military turnover was the Continental Can Company hangar, which is the large hangar in the above picture. To the left of the hangar are the original Charlie taxiway and two Quonset hut-type hangars. The air traffic control tower was located between the Quonset hut hangars. The building on the lower left is the original airport administration building. (Jim Gieger.)

FUTURE DEVELOPMENT. The next hangar to be built was the Keyes Fibre hangar, located to the right of the Continental Can Company hangar. Also in view is the west tie-down area, with five rows of T-hangars. Many of the aircraft that were tied down on the grass in the earlier picture were moved to the west tie-down area to make room for more hangar development. (Jim Gieger.)

EARLY 1950s. In this early-1950s photograph, the word "Morristown" appears just below the runway intersection, giving pilots overhead a clue as to their whereabouts. Beneath the word is the number 203. Presumably this is the mean sea level (MSL) of the airport. The airport has seen wetland areas develop where none had been before, and the filled land has settled over 70 years. Today the airport sits at 187 feet MSL. (Jim Gieger.)

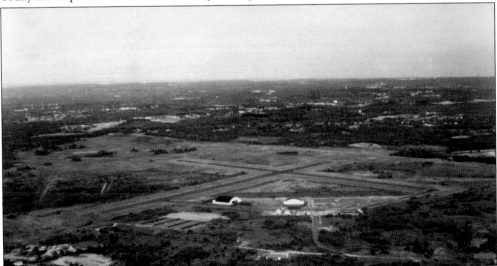

AIR TRANSPORT HANGAR, C. 1954. This March 1954 photograph shows miles of open fields. The former Continental Can Company, Inc., hangar and a lone Beech 18 are the only hints that an airport is nearby. The clear area in the upper left background will eventually be developed for runway 5-23 under a 1969 federal grant. (Jim Gieger.)

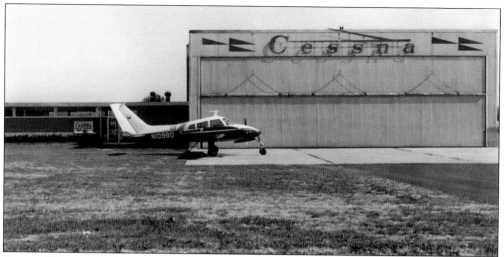

CESSNA HANGAR. In the 1950s, another growth spurt began. Continental Can Company decided to base its fleet of private corporate aircraft at Morristown Municipal. The decade ended with a new hangar erected by Cessna, which opted to establish its East Coast depot there. (MMU.)

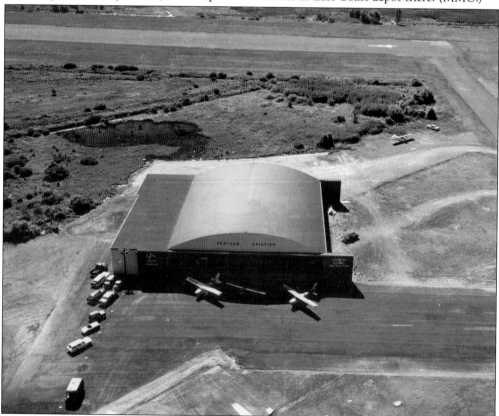

CHATHAM AVIATION. Chatham Aviation operated a flight school, maintenance shop, and charter flights out of this hangar. While not one of the earliest hangars built at MMU, this was one of the first hangars erected in the second phase of major development at the airport when Morristown took over operating the airport after the war. (NJAHOF.)

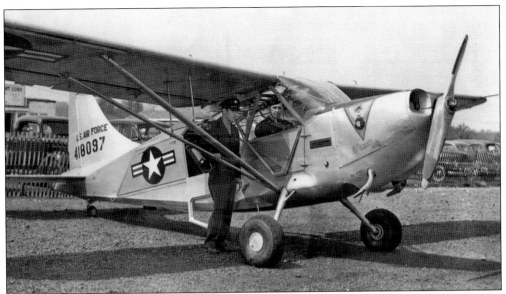

BIRD DOG. The Cessna L-19/0-1 "Bird Dog" was built between 1950 and 1959. It was used over the years in various configurations from artillery observation to dual and instrument training. It is possible that these two air force officers were doing recruiting at Morristown Municipal Airport, since the air force never had a permanent presence there. (MMU.)

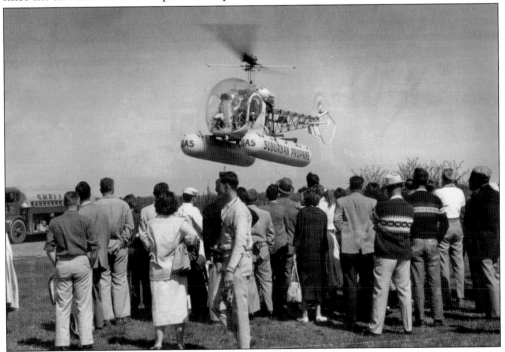

BELL 47 HELICOPTER. During the four-hour 1956 air fair, several manufacturers had new, private aircraft on display. Helicopters, such as this Bell 47 belonging to Suburban Propane Gas Company, thrilled the crowd. The helicopter was used on pipeline patrols. Other organizations such as the Port Authority and the U.S. Army were on the field. Several antique automobiles were also on the tarmac. (Jim Gieger.)

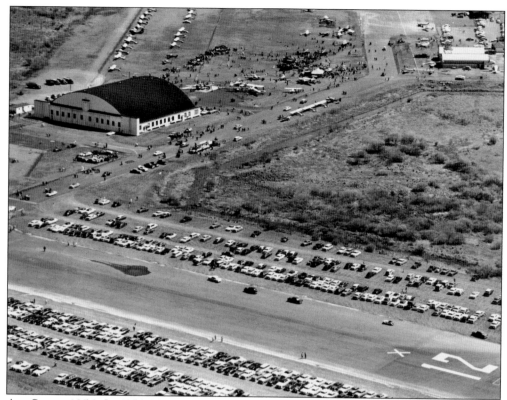

AIR SHOW, 1956. In 1956, Morristown Airport celebrated its second annual Air Fair. Morris County had become a leader in research on aircraft radio and control instruments. According to the *Daily Record*, an estimated crowd of approximately 10,000 turned out for the event, which was touted as a huge success. Note the "X" on runway 12; it indicates to an incoming pilot that the runway is closed. (MMU.)

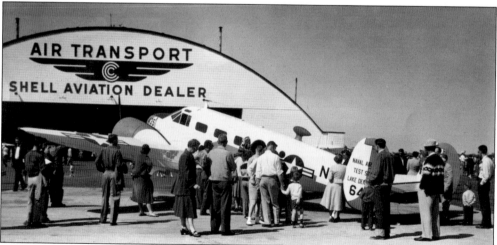

AIR FAIR. Morristown Municipal Airport played host to many of the aviation firms in Morris County. At the time, these firms made Morris County a leader in the research and development of aviation technology. The airplane in front of the hangar drawing lookers is a navy (AT-11) SNB-1, the military version of the civilian Twin Beech 18S. (Jim Gieger.)

A 1956 CHEVROLET. The Whipponong Post No. 155 of the American Legion sold raffle tickets for this fully equipped 1956 Chevrolet Bel Air four-door sedan. Tickets were 50¢ each at the May 20 Air Fair. The three legionnaires are, from left to right, ? Ozinkowski, Tony Baranowski, and Pete Zailo. (Jim Gieger.)

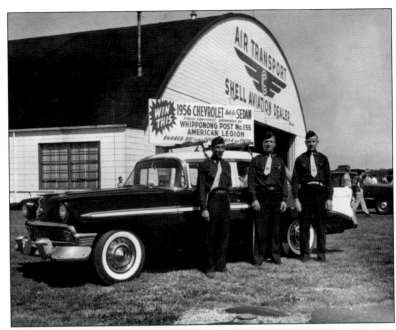

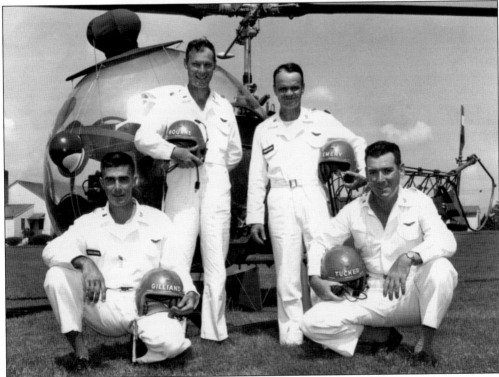

U.S. ARMY HELICOPTER SQUARE DANCE TEAM. Harry E. "Ned" Gilliand Jr.'s (kneeling, left) flying experience began with a weekend job as a line boy at Morristown Airport, where he worked for rides and flight instruction. In 1953, Gilliand went to army helicopter flight training. In 1955, he joined the Army Helicopter Square Dance Team, performing at numerous air shows. One of the four modified H-13s, the military version of the Bell 47 the team used, is behind them. (MMU.)

THE OBSERVER

MORRISTOWN POST
GROUND OBSERVER CORPS

Vol. 1 No. 3 October 1956

FLASHES FROM THE TOWER

OCTOBER MEETING

On October 8th over 30 observers attended a meeting held in the new Morristown Trust Company building on South Street. Our Supervisor, Seymour Saltus, told us that we had obtained quite a few new observers as a result of the Morris County Fair and Civil Defense Week. All observers, old as well as new, were given the pledge by S/Sgt James Spellman, USAF.

Awards were presented to the large group who have served 20 hours and to smaller groups who have earned the 100 and 250 hour awards. Bill Walton was presented with his pin for 500 hours. This is particularly noteworthy, as Bill has served 500 hours in less than six months. Such devotion to duty deserves a great deal of praise.

Seymour Saltus suggested that the teen-agers among the observers organize a special group. As this met with favor, Dave Mutchler and Harry Hatton were appointed as temporary co-chairmen.

Sgt. Spellman told us all about the operation of the Message Center at Trenton, N.J. Due to the change from White Plains to Trenton the number of calls received have risen from 60 to between 600 and 1000 an hour. He explained that if our calls are not answered in a minute, they are automatically switched to Baltimore, Md. A three to four minute wait causes the call to be transferred to New Haven, Conn. and a delay of four to five minutes relays the call to the Eastern Air Defense. Then the delay is immediately investigated. Telephone service to the Trenton Fileter Center costs about $28,000 a month.

An excellent film entitled "The Dangerous Mile" was shown. It pointed out the importance of the work we are doing by explaining the relationship between a typical Post and the whole Defense System. After an informal discussion of the operation of the Post, questions were answered by Sgt. Spellman. A committee composed of Mrs. Radice, Mrs. Havness, Miss Porter, and Miss Haydu served coffee and doughnuts.

CHANGE TO STANDARD TIME

On Sunday October 28th at 0200 it will be actually only 0100. There will be more light for those of us on the 0600-0800 shift and earlier dusk in the evening.

1

THE OBSERVER. The Morristown Ground Observer Corps (GOC), formed during the 1950s to address the perceived threat of the cold war, held meetings in a building in Morristown and observed the skies from the control tower. At the height of the GOC program, there were more than 25,000 observation posts located approximately every 8 miles across the United States. (From the collections of North Jersey History Center, the Morristown and Morris Township Library.)

GOC—CD. The Morristown Ground Observer Corps was part of the national civil defense network and supplemented the nation's radar system, which was designed to detect a Soviet Union bomber attack against the United States. Initiated in the early 1950s, the corps was organized and directed by the U.S. Air Force. (From the collections of North Jersey History Center, the Morristown and Morris Township Library.)

38

ARMBAND. The Morristown GOC operated from the airport tower from 1952 until 1959. Civil defense messengers relayed messages from the tower to the GOC office in Morristown. Until 1958, the GOC manned its observation posts 24 hours a day, seven days a week. Then, in 1958, because of improved radar and the electronic networks, the air force scaled back observations. (From the collections of North Jersey History Center, the Morristown and Morris Township Library.)

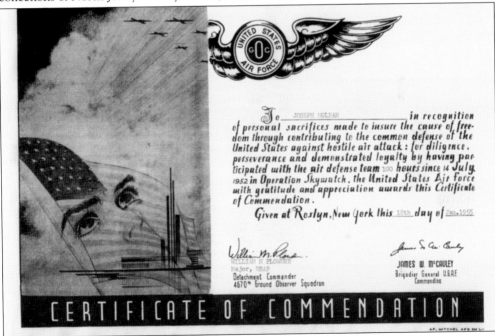

CERTIFICATE OF COMMENDATION. Joseph Molnar participated in the Ground Observer Corps at the Morristown Post from 1954 to 1959. He was awarded several citations for his service. This certificate was for 100 hours of service. In addition to his service in the GOC, Molnar also actively participated in Morristown Civil Defense, another municipal federal effort to protect citizens in the event of a Soviet attack. (From the collections of North Jersey History Center, the Morristown and Morris Township Library.)

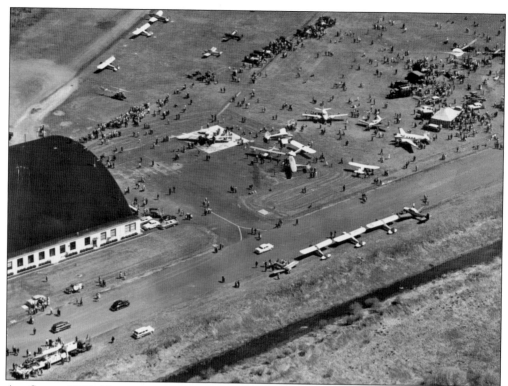

AIR SHOW, 1956. Newspapers reported that the air show ground traffic clogged the roads with hundreds of cars for hours. Several hundred more autos were parked near the runways, while their occupants walked through the exhibits of airplanes. The air show committee reported that 1,300 cars were parked in the official area, and the snarl of traffic resulted in a call for extra police. The air show recruited several dozen volunteers for the GOC. (MMU.)

USAF C-47. This air force C-47 was on hand for the 1956 Air Fair. During World War II, the C-47 and other army aircraft used Morristown Airport. The army invested in the airport's infrastructure and maintenance facilities for their aircraft, such as this C-47. After the war, with the infrastructure in place, the airport began to grow. (MMU.)

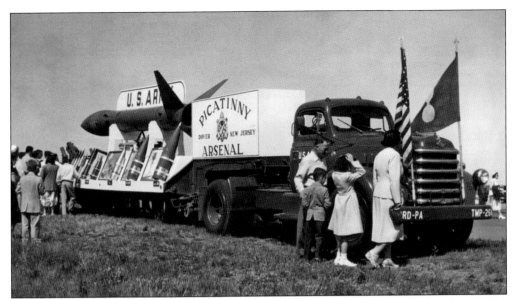

NIKE MISSILE TRANSPORTER. At the second annual Air Fair, the U.S. Army displayed one of the front lines of defense, the formidable Nike missile. The Picatinny Arsenal in nearby Dover trucked in an example of the missile. A navy blimp from Naval Air Station Lakehurst and a formation of jet fighters flew over the field. (Jim Gieger.)

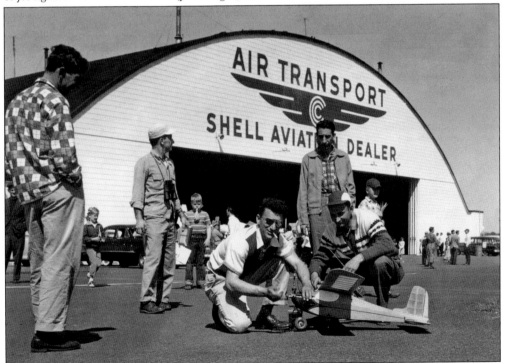

MODEL AIRPLANE. The early air fairs often drew a healthy group of radio-control model-airplane builders and enthusiasts to show off their hobby. Here the nearby Roxbury Area Model Airplane Club performed demonstrations of radio-controlled aircraft models that included antique, military scale, and aerobatic types. There were 48 full-sized airplanes on exhibit. (Jim Gieger.)

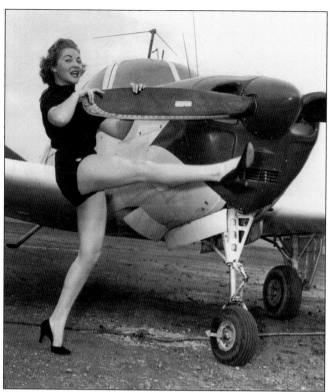

HAND PROPPING AT THE 1956 AIR FAIR. This model, supplied by the airport committee of the Morristown Area Chamber of Commerce, is demonstrating with her leg raised, an exaggerated textbook stance for hand propping an engine to life. Hand propping was a method often preferred over the hand crank since the days of the Wright brothers and the relatively heavy, complex, and expensive electric starters. (Jim Gieger.)

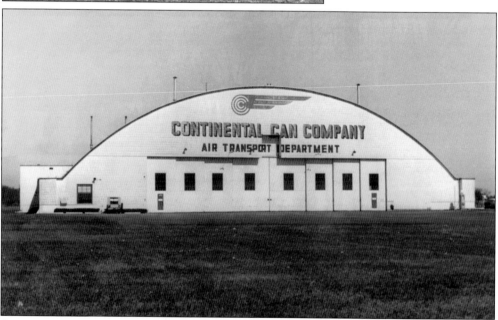

CONTINENTAL CAN COMPANY HANGAR. The question on the minds of the people of Morristown was whether the airport would pay for itself or the taxpayers would end up footing the bill. Shortly after this hangar was built, the airport began earning a profit. By 1960, it expected to earn a profit of $70,000. This trend did not continue, and eventually Morristown leased the management of the airport to DM Airports, Ltd. (Jim Gieger.)

MMU, MID-1950s. This photograph shows the former Teterboro tower nestled between the two small hangars in the lower part of the photograph. The Keyes Fibre hangar is present in this photograph, and the big hangar to the left is the Continental Can Company hangar. (MMU.)

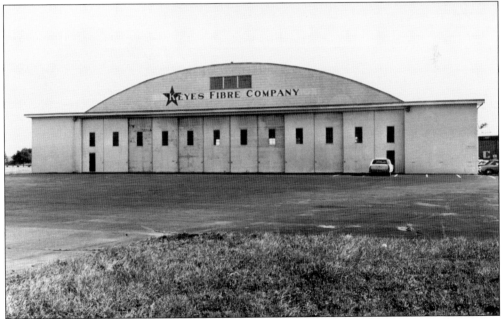

KEYES FIBRE COMPANY HANGAR. Keyes Fibre Company produced paper products such as egg trays, bottle packs, and containers for light bulbs. After World War II, Keyes continued expanding its product line. Keyes was turning out millions of pieces a year in more than 400 designs of molded pulp and plastic by the 1950s, and the company used Morristown to forward deliveries throughout the world. (MMU.)

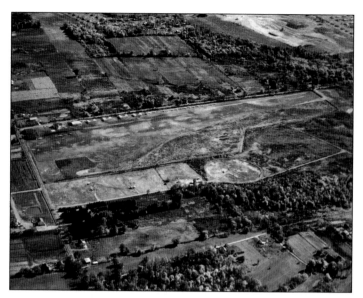

LINCOLN PARK, C. 1960. In 1940, while there was little more than talk about an airport in Morristown, just over 15 miles away in Lincoln Park was a functioning airport, with four flying clubs and 200 pilots logging 2,500 hours. After the war, its single 2,600-foot paved runway attracted hundreds of pilots. Looking southeast, little has changed, and today it remains one of the few privately owned public-use airports left in the state. (NJAHOF.)

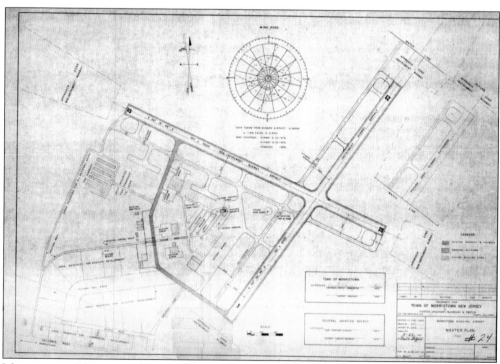

MORRISTOWN MUNICIPAL AIRPORT MASTER PLAN. This blueprint, dated March 22, 1960, shows the planned future growth of the airport. There are areas designated for helicopters, a future beacon, control tower, and the National Guard. Although military airplanes were stored after the war, there has never been a permanent military presence at MMU. In the upper right, a future 2,000-foot extension to runway 23 is indicated. The extension would be built toward the end of the 1960s. (MMU.)

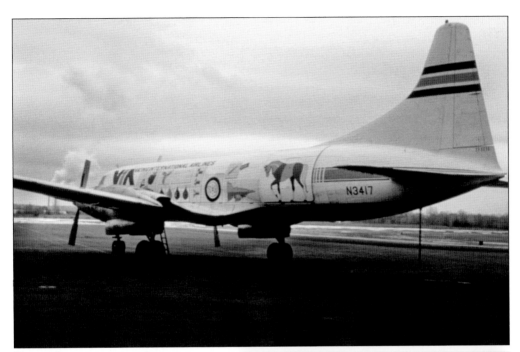

VIKING INTERNATIONAL AIRLINES. In the 1960s, Convair 640s, like this Viking International Airlines airplane, were transient guests at Morristown Municipal Airport. It was also during this period that residents surrounding the airport began to see increased traffic and larger airplanes like this Convair and the early business jets. (MMU.)

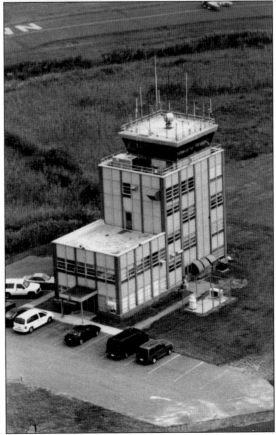

AERIAL OF CONTROL TOWER. The current five-story control tower was built in 1960 and was dedicated on October 27, 1961. It currently has 12 air traffic controllers, one frontline manager, and one air-traffic manager. There are six technicians who are airways and facilities personnel, and they are responsible for maintaining navaids around the area and FAA equipment in the tower. (MMU.)

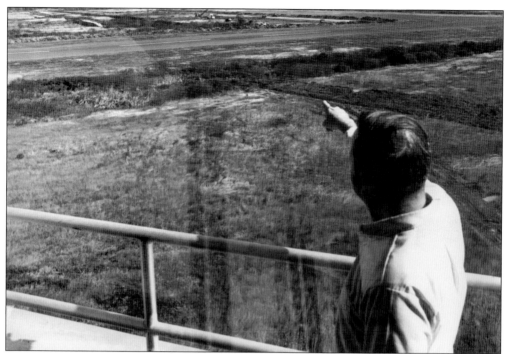

CONSTRUCTION, 1960s. An airport official points to the new construction on the west side of the field in the late 1960s. In 1931, the aldermen had to decide whether the 200 acres in the meadowlands that were part of the Normandy and Whippany Water Company purchase would become a golf course or an airport. The decision was to build an airport, and some Depression funding had gone into draining and filling the area, but work was slowed in 1935. (MMU.)

RUNWAY CONSTRUCTION, 1965–1969. Workmen on two bulldozers can be seen on the right middle of the photograph working on taxiway alpha and the runway 23 extension. In spite of contentious lawsuits around that time, the federal government gave the airport $3,612,809 for taxiway work and a runway extension that started in 1969. (MMU.)

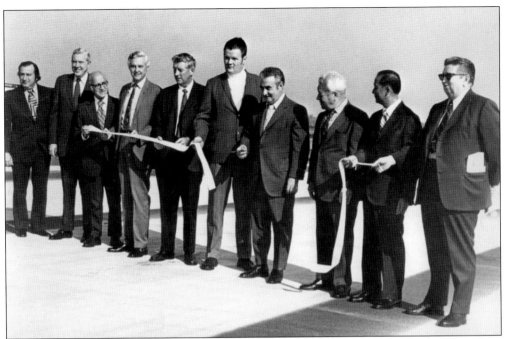

RIBBON CUTTING AND RUNWAY 23 REOPENING. From left to right are two unidentified, Mayor Ray De Chiara, Russ Mascostirone, Bernard Noncarro, William Flanagan, Anthony Cataro, Com Morchower, Henry Lamb, and airport manager Robert McGovern. The event celebrated the expansion of runway 23, which included a new ILS system, runway edge markings, taxiway extension, and a Medium Approach Lighting System with Rails (MALSR) system. (From the collections of North Jersey History Center, the Morristown and Morris Township Library.)

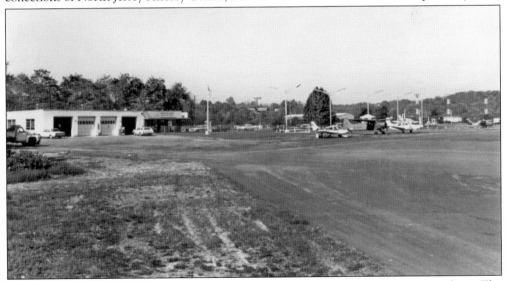

AIRPORT IMPROVEMENTS. This is the original operations building, with ramp area in front. The operations building and control tower were constructed around the same time and had grand openings in October 1964. In February 1969, Morristown approved a $3.2 million bond to be used for taxiway improvements, an instrument landing system (ILS), and improvements in the airport's lighting system. The west tie-down area is off in the distance. (MMU.)

47

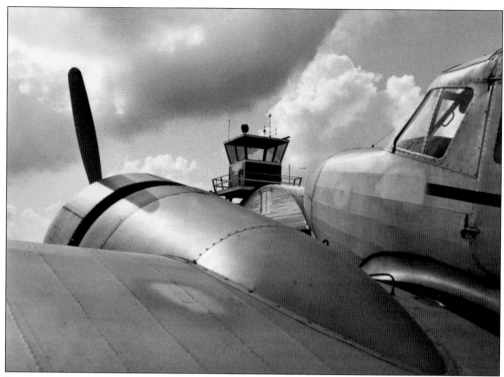

BEECHCRAFT AND TOWER. Morristown Airport was on its way to becoming a glamour airport and a VIP stop. It handled hundreds of airplanes, from piper cubs to large four-engine DC-6s. Small jets were appearing on the scene and foreshadowed the corporate jet traffic to come. (Jim Gieger.)

AIRPORT DIRECTOR ROBERT McGOVERN. From 1957 until his death in 1980, Robert P. McGovern served as airport manager. McGovern saw the facility grow and once remarked, "the key to the future development of Morris County lies in the access that major corporations have through the airport." In May 1980, a move was made to rename the airport for him. In what the *Star Ledger* reported as a dramatic and premature effort, the proposal was defeated by a tie, 3-3, vote. (MMU.)

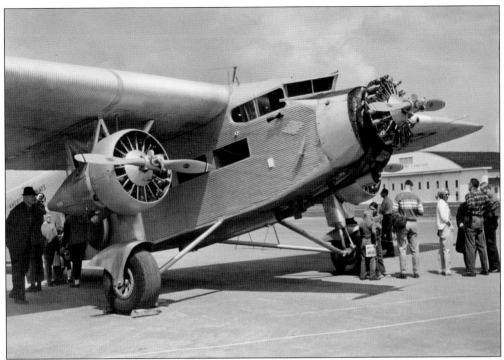

FORD TRI-MOTOR AT MMU. In 1964, American Airlines took a Ford Tri-Motor on a national tour to celebrate its 40th anniversary. It landed one of its original Fords at Morristown Airport on April 25, 1964. American Airlines was originally called American Airways, but in 1934, an airmail scandal caused all the airlines to change their names. Behind the airplane is the Keyes Fibre Company hangar. (NJAHOF.)

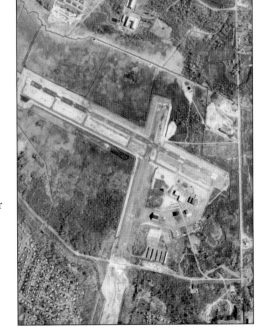

AERIAL OF AIRPORT, c. 1971. On the extreme right is Columbia Turnpike. In the right center is the Chatham Aviation hangar. In 1970, the runway 23 extension (on the left) decreased the number of airplanes using the shorter east-west runway, which produced most of the noise complaints. When the extended runway opened, 95 percent of Morristown Municipal's flights would take off and land over the open areas toward Routes 10 and 287. (MMU.)

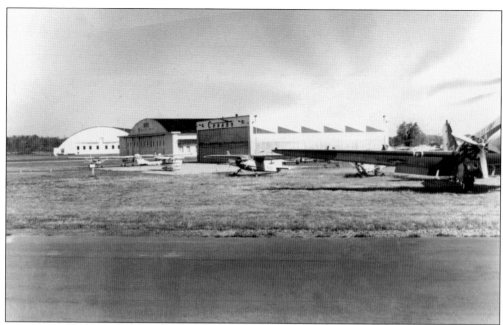

AIRPORT GROWING. In July 1969, Hanover Township, Morristown, Florham Park, and six members of the Citizens for a Smaller Morristown Airport filed a lawsuit jointly to block the expansion of the runway and facilities to accommodate medium and short-range jets. A judge ultimately ruled in favor of the airport, but the expansion issue continued for years. The hangars are Cessna, Keyes Fibre Company, and, in the rear, the former Continental Can Company hangar. (MMU.)

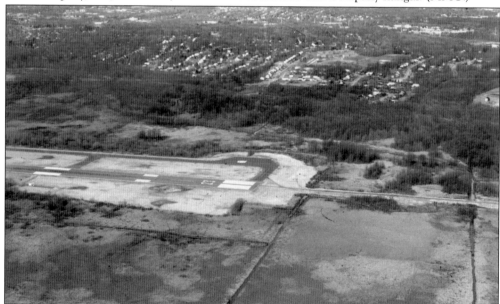

AIRPORT EXPANSION. In 1969, an expansion program was proposed to lengthen the main runway. By 1972, that project had been completed, and the runway was taken from 4,000 to 6,000 feet. In addition, modern lighting and an ILS system were installed to guarantee safe, all-weather operations. The ditches were used to divert the old Monroe Brook and to help the wetland areas drain into the Black River. (Carl Laskiewicz.)

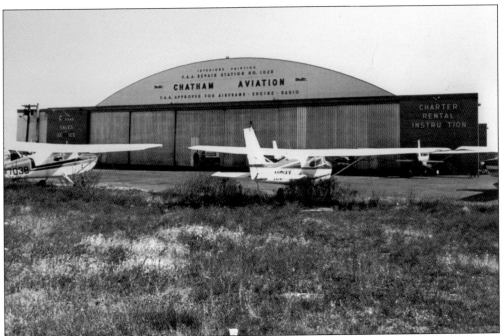

CHATHAM AVIATION. This hangar was one of the front three that faced the main runway. Eventually all were operated by Lynton, then Signature Flight Support. They were all dismantled to make way for Signature Flight Support's Hangar 1. Throughout the 1960s and the 1970s, Morristown Air Transport, Monmouth Airlines, Transcom Airways, and Southeast Air all began air-taxi service out of Morristown to Newark, LaGuardia, and Kennedy Airports. (MMU.)

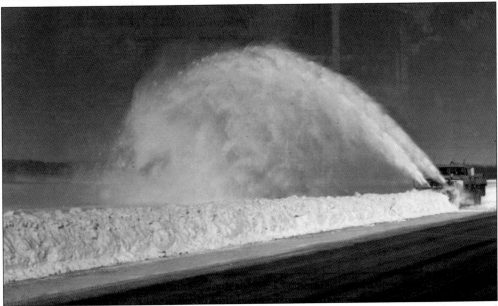

SNOWSTORM, 1970s. This photograph from the 1970s is of one of the original truck-mounted snow blowers used by MMU. Taxiway, runway, and airfield signs are not very high, and a heavy snow tends to block them. The snow blowers are used to throw the snow up and over the lights and signs so they are not blocked and 1,000 lights do not have to be dug out by hand. (MMU.)

EARLY AIRLINES. In the early 1970s, fledgling airlines began using Morristown as a base. In February 1971, Monmouth Airlines began service to Newark and Kennedy with Piper Navajos and Britten Norman Islanders. Southeast Air, Inc., began service to Boston in February 1979. Other airlines and corporations used Piper Aztecs (pictured here) to shuttle executives from their corporate headquarters to various points around the country. (MMU.)

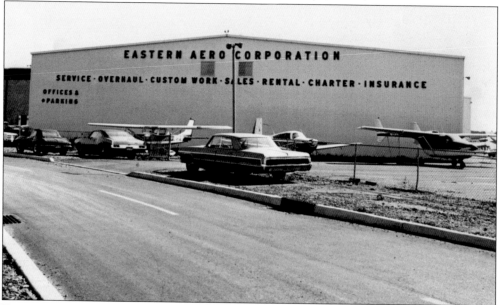

EASTERN AERO CORPORATION. With the construction of the Continental Can Company hangar in 1951, Morristown Airport began to prosper. The 1960s saw a boom in construction. In 1960, Chatham Aviation built a hangar, and in 1962, Blanchard Securities built one as well. In 1962, Eastern Aero Corporation erected two more hangars. (MMU.)

Two

THE JET AGE
1961–1990

LOCKHEED JETSTAR AND CONVAIR 540. The Lockheed JetStar 731 (in the foreground) and the Convair 540 represented the new and the old in the 1960s. The JetStar was the first business jet, and Convair attempted to compete with the new jets by upgrading its older C-340s to turboprop technology. A four-engine JetStar entered service in early 1961. (NJAHOF.)

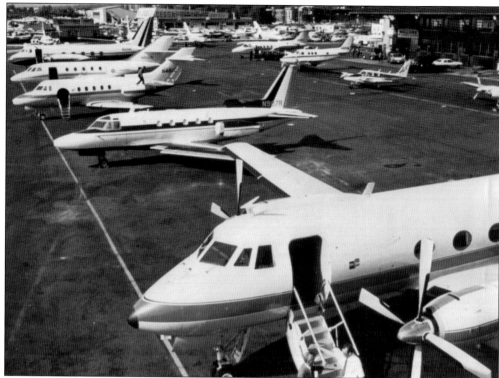

TETERBORO AIRPORT. While Teterboro Airport, approximately 27 miles east of Morristown, has been the scene of countless pilot-training flights, its proximity to the large commercial airports has forced these operations to smaller airports. Student pilots could not afford to spend 30 minutes on the ramp waiting for corporate traffic to clear so they could take off. They eventually migrated to other airports such as Morristown, where they can take off almost immediately. (MMU.)

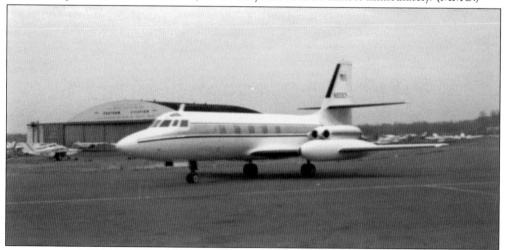

LOCKHEED JETSTAR 731. In the early 1970s, jets were rapidly replacing piston-engine aircraft at Morristown. The jet engines created a contentious issue between the residents of the surrounding communities and the airport operators. Lawsuits ensued, and for years the plaintiffs and defendants argued their positions. Ultimately, voluntary noise-abatement rules and restricted-use times moderated the issue. (MMU.)

CONTINENTAL CAN AND NABISCO JETS. In the 1950s, Continental Can Company decided to base its fleet of private corporate aircraft at Morristown. By the early 1960s, jet aircraft noise was a contentious issue. The surrounding townships took Continental Can Company to court to try to halt its use of company jets. FAA rules forbid courts from directing airports to control noise. Courts can make a request, but all noise abatement is voluntary. The airport dealt with the issue by voluntarily implementing an abatement program. (MMU.)

FLYING IN LINDBERGH'S TRACKS. On Sunday, June 16, 1985, seventy pilots embarked on a 4,781-mile adventure from Morristown that would end in Paris the following Sunday. While the pilots did not attempt the trip as Lindbergh did (i.e. nonstop), they competed for a $20,000 purse for precision flying. The airplanes involved were all privately owned and typical of this twin-engine Piper Aztec. (Jim Gieger.)

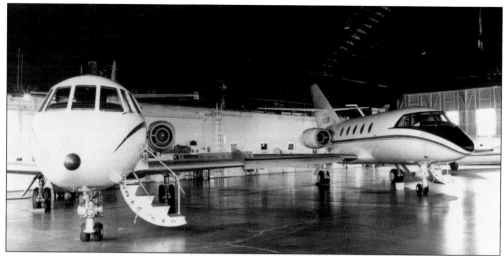

CONTINENTAL HANGAR. The old Continental Can Company B-24 corporate aircraft has been replaced in this 1970s photograph with the company's Falcon 20 (left). Nabisco's corporate aircraft was also a Falcon 20. These were early serial number Falcon 20s. Falcon, whose U.S. office was in Teterboro Airport, operated a maintenance facility in the old Hangar 5. (MMU.)

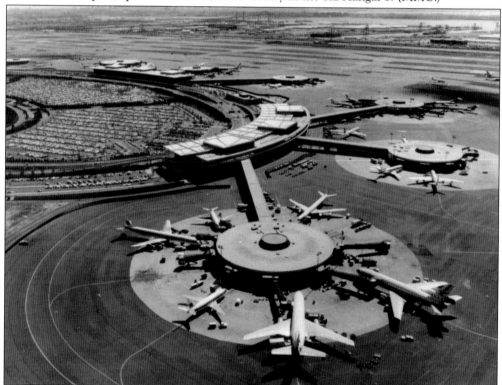

NEWARK AIRPORT. Morristown Municipal Airport's course to the future was set despite its opponents. In 1972, the federal and state governments included Morristown Municipal Airport in their airport plans as "a primary back-up facility for flights unable to land at Newark, LaGuardia, or Kennedy International Airports." Today Newark Airport occupies 2,027 acres; 880 acres of this total was acquired by the Port Authority after it began operating the airport in 1948. (NJAHOF.)

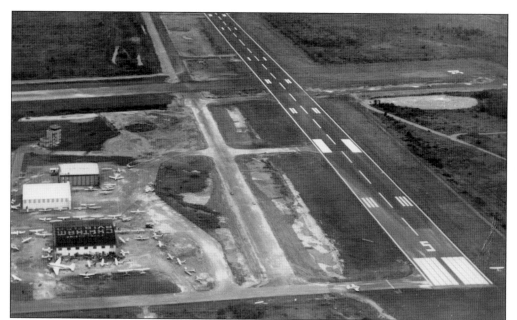

TAXIWAY ALPHA UNDER CONSTRUCTION. This photograph, taken in the early 1970s, shows runway 5-23 with taxiway alpha to its left, under construction. The Chatham Aviation hangar is on the lower left with a Douglas DC-3 alongside the hangar. At this point, there are dozens of small Piper and Cessna aircraft, and the airport had not yet taken on the look of a busy corporate airfield. (MMU.)

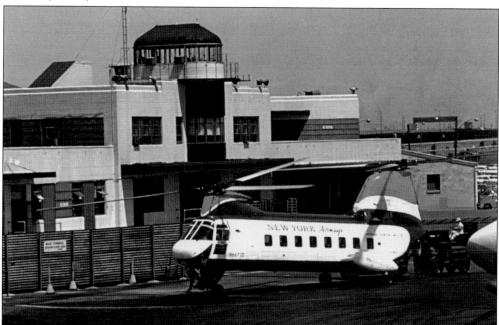

NEW YORK AIRWAYS HELICOPTER AT TETERBORO. New York Airways was the first scheduled helicopter service in the United States, and it began in 1974 with 20 scheduled flights from Teterboro to Newark, LaGuardia, JFK, and Morristown Airports. For $15, one could check in at Morristown with bags and fly to any of the three major airports and catch a flight. (NJAHOF.)

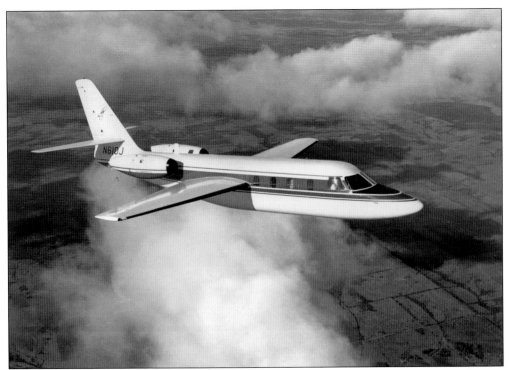

AERO COMMANDER 1121 JET COMMANDER. N610J was the first of two prototypes built by the Aero Commander Company and was one of the first business jets made in the United States. This aircraft was one of the many transiting MMU. In May 1960, a local newspaper article on the success of the airport as a revenue earner cited 18 Morris County companies based at the airport and another 24 companies as transient customers. (Jim Gieger.)

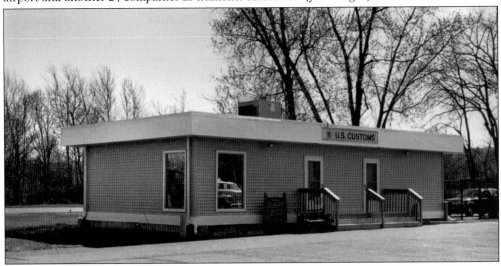

CUSTOMS BUILDING. In July 1978, the prospect of Morristown becoming a stop on international flights caused the U.S. Customs Service to announce that Morristown Municipal Airport would be handled by its New York regional office, allowing "local (Customs) people . . . to serve a local airport" on a part-time basis. In 1988, it became a full-time position. Today, in addition to handling Canadian flights, MMU can handle the larger corporate jets from Europe. (MMU.)

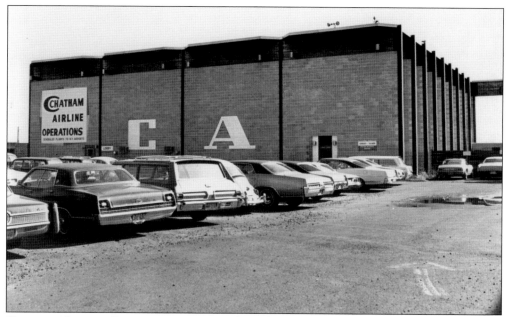

CHATHAM AIRLINE OPERATIONS, C. 1960. Throughout the 1960s and 1970s, major changes and challenges came to what had been a small airport. In February 1970, a Handley Page Jetstream departed MMU for Washington, D.C., cutting travel time to the city to less than an hour. The fare was $35, compared to the shuttle flights from Newark that cost $22. The Newark flight required more time and expense getting to the airport compared to the ease of access to MMU. (MMU.)

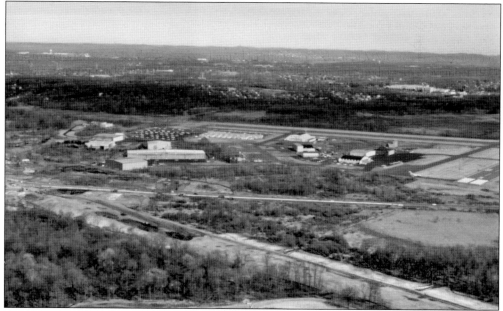

ROUTE 24 UNDER CONSTRUCTION. Route 24 is under construction in this photograph. The buildings in the distance are in Morristown. Originally, with the airport traffic growing, plans were made to build a hotel just off the airport alongside Columbia Turnpike. The condemnation of 7 acres for the interchange, along with the passage of wetlands-development prohibitions, halted implementation of the plan. (Carl Laskiewicz.)

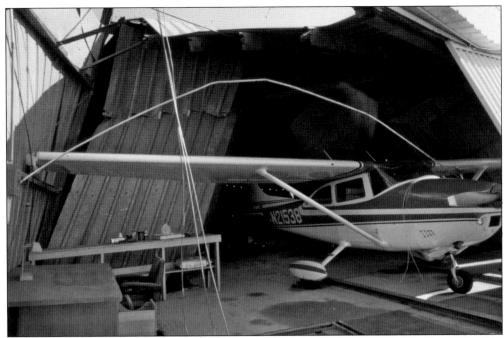

CRUSHED AIRPLANE. Cessna N21538 lies crushed under a collapsed hangar resulting from 70-miles-per-hour winds that battered Morristown Municipal Airport on Thursday, April 1, 1982. The meteorologist at the airport, Frank Lombardo, said the hurricane-like winds began late Wednesday night and continued through Thursday afternoon. Lombardo said the short gusts of wind were more damaging than steady winds, since the gusts caused things to bounce back and forth, creating more problems. (MMU.)

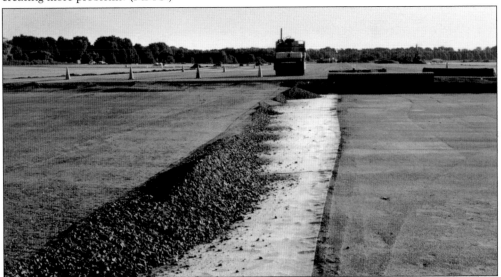

EMERGENCY RUNWAY REPAIR. This is a repair to runway 23. The paved piece toward the back is the extension of the runway built in the 1970s. The section that is removed was where the original runway joined the extension. Due to poor subgrade, the joining point sunk, causing a dip in the runway. This repair corrected the dip. Note that stone was placed on top of fabric to increase the stability of the subgrade. (MMU.)

DC-3 N3HA. This DC-3 was NC33632 serial No. 4138 for Eastern Airlines as ship 375. It went through six companies before being reregistered in January 1975 with the American National Bank and Trust Company in Morristown, New Jersey. The following year, it was sold to Clarkesville Flying Service, Inc., in Nashville, Tennessee. (Robert Vanderhoof.)

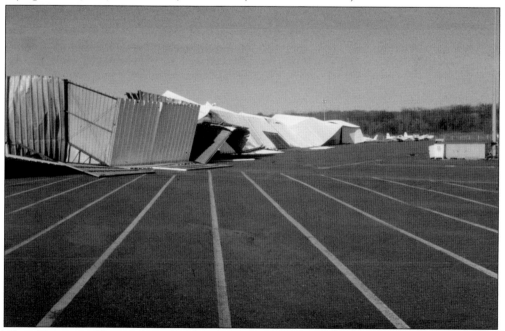

WIND TOPPLES A HANGAR. On April 1, 1982, seventy-mile-per-hour winds battered Morristown Municipal Airport. The winds knocked over trees, which took down power lines, along with this 300-by-40-foot, corrugated steel hangar and twisted it like a pretzel. The wind pushed the structure some 30 feet from its foundation. Airplanes were damaged, but there were no injuries. The airport manager said there was no warning. (MMU.)

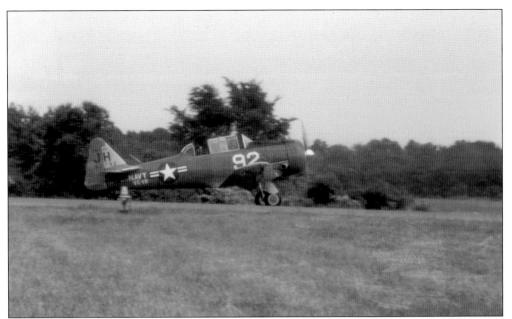

AT-6 (SNJ). Shown here is one of the Six of Diamonds flight team that performed at the Air Fair. The airplane's eye-catching color scheme of dark-grey fuselage, yellow wings and tail, and dark orange engine cowling and rudder made it easy to follow during its maneuvers in the sky. The team performed solo aerobatics, historic honor salutes, fighter attacks, and more. (Henry M. Holden.)

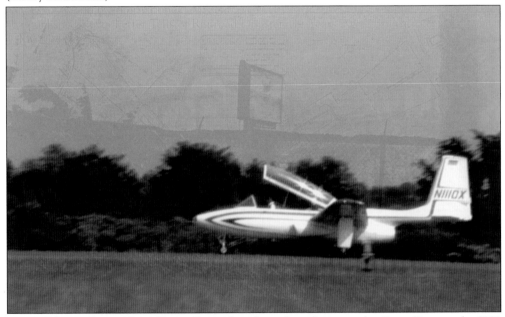

N1110X Super Pinto. Capt. Harry Shepard performed aerobatics in this Super Pinto at the 1983 air show. With a modified navy jet-powered primary trainer, Shepard performed a 500-mile-per-hour low pass, hesitation rolls, spectacular loops, Cuban eights, and vertical eights that would have been impossible with a propeller-driven airplane. The Model 51 Pinto was nicknamed "Tinker Toy." (Henry M. Holden.)

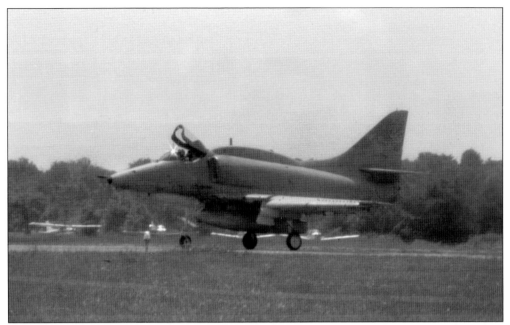

MORRISTOWN MUNICIPAL AIRPORT'S LAST AIR SHOW. This A4 fighter jet appeared at MMU's last air show in 1983. Unfortunately MMU is no longer well suited for an air show. There is only one road in and out, which is difficult for traffic and especially difficult during an emergency. Also, with the number of private corporate lease holders at the airport, there is nowhere to put a large volume of visitors. (Henry M. Holden.)

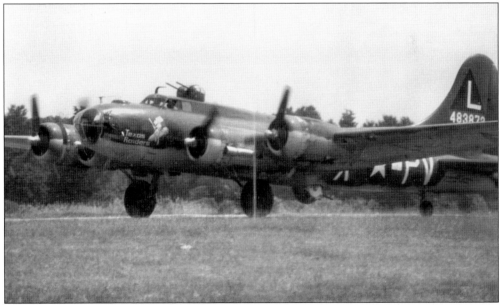

B-17 TAKEOFF ROLL. At the time the B-17 Flying Fortress Texas Raiders appeared at the Morristown Air Fair in June 1983, there were only one or two still able to tour the country out of more than 12,731 that were originally built. This airplane belonged to, and was supported by, the Confederate Air Force, a nonprofit organization headquartered in Rebel Field, in Harliquin, Texas. (Henry M. Holden.)

B-25 Bomber. This World War II B-25 Mitchell was part of the flyby show at the 1983 Air Fair. It won first place at the 1982 Oshkosh, Wisconsin, competition as the "Best Bomber with Original Markings." The B-25 was used in the Doolittle raid over Tokyo. The movie *30 Seconds over Tokyo* was based on this event. (Henry M. Holden.)

MORRISTOWN
MUNICIPAL
AIRPORT

JUNE
11-12 '83

**AIR
SHOW**

AND AVIATION EXHIBIT

Air Show Cover, 1983. The Air Fair also celebrated the bicentennial of flight. On November 21, 1783, a French balloonist named Etienne de Montgolfier made the first manned flight in history when he soared aloft in a hot air balloon over La Muette, France. The hot air balloon was one of the only aircraft types not at the show. (MMU.)

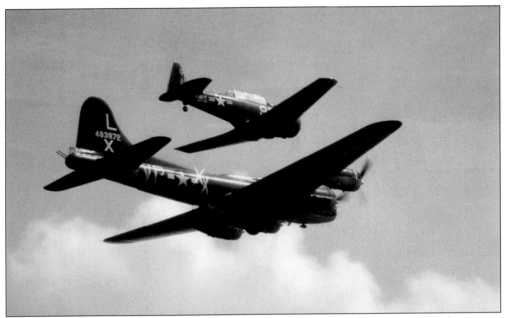

B-17 AND NAVY SNJ. In 1983, MMU held its last two-day air show. There were 20 pilots giving charity rides for $7 per passenger. At approximately 11 a.m. on Saturday, the Boeing B-17 Texas Raiders and the North American AT-6 (SNJ), one of four in the show, were part of the military flyby. (Henry M. Holden.)

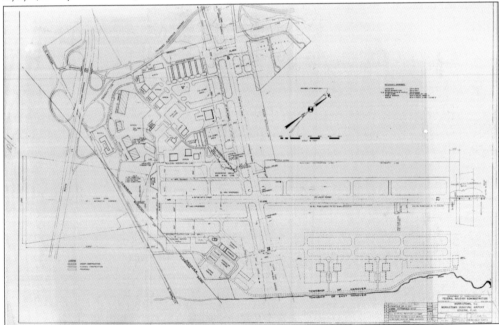

AIRPORT GENERAL PLAN. This FAA eastern region map of Morristown Municipal Airport was used to provide information on airport improvements over the years. Created in 1970, this map was updated seven times through 1984. It not only shows the infrastructure of the airport, but also lists such improvements as a glide slope and updated runway 5-23, and it added a revised MALSR middle marker. (MMU.)

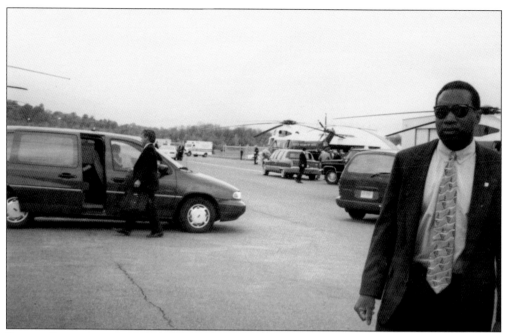

SECRET SERVICE ON GUARD. Many presidents, vice presidents, and candidates have landed at Morristown while on the campaign trail. With them go the ubiquitous Secret Service and its unflinching agents. At least three agents, and in the distance a marine guard, are present. The presidential helicopter, *Marine One*, is in the background. (MMU.)

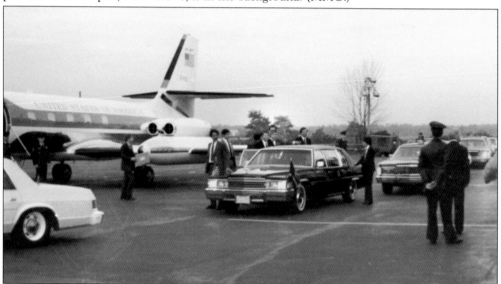

PRES. RONALD REAGAN DEPLANING FROM VC-140B, 1981. Six VC-140Bs flew on special government and White House airlift missions by the 89th Military Airlift Wing at Andrews AFB, Maryland. The VC-140B carried presidents Nixon, Ford, and Reagan a number of times into MMU. Although it was not the primary presidential aircraft, whenever the president was aboard, it flew under the radio call sign *Air Force One*. Here President Reagan has deplaned and is about to enter the limousine. This was President Reagan's first appearance after surviving an assassination attempt in March 1981. (MMU.)

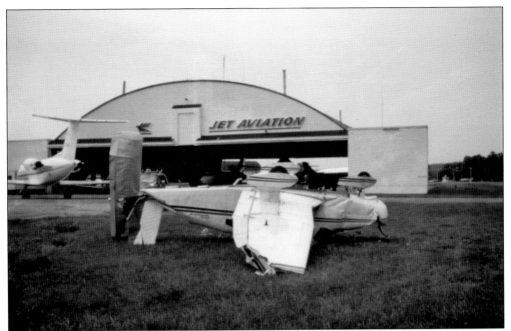

LANDING ACCIDENT AT MMU. According to the National Transportation Safety Board (NTSB) report, the student pilot of this airplane said he encountered a sudden shift in the wind from the east as he was landing. He said this caused the airplane to tip to his right and come to rest on its roof. The wind was at 7 knots, visibility was unlimited, and he was not hurt. (MMU.)

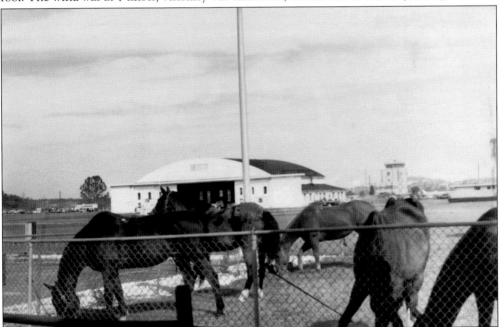

HORSES. Morris County is a heavily wooded county in northern New Jersey, and some areas are patrolled by park police on horseback. These horses were used by the Secret Service and Morris County police when President Reagan came to Morristown Airport. They are grazing in front of the airport operations building while awaiting the arrival of the president. (Robert Vanderhoof.)

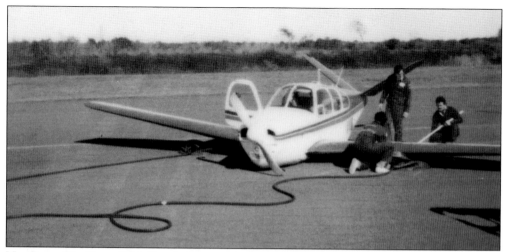

No Gear, No Fear. This Beech Bonanza landed safely at Morristown Airport in June 1984 with one of the three wheels on its landing gear missing. The pilot was on his final approach when an audible warning alerted him to the problem. He aborted the landing, and the tower confirmed that one of the landing gear did not extend. Maintenance personnel utilized airbags to lift the aircraft up and lower the landing gear down so that they could tow the airplane to the maintenance ramp. (MMU.)

Riegel Paper Company Executives. Standing in front of their corporate aircraft based at Morristown Municipal Airport are, from left to right, unidentified, Joe Gieger, Sid Taylor, Walt Stromier, and unidentified. The old Riegel Paper Company Mill was built at Hughesville on the Hunterdon County side of the Musconetcong River. MMU was used to ship the company's products. (Jim Gieger.)

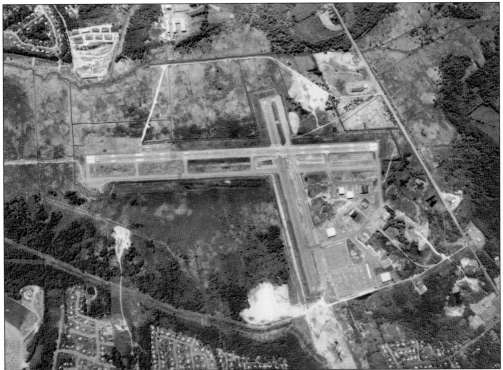

ROUTE 24 INTERCHANGE. The solid diagonal line at the bottom of this photograph is Columbia Turnpike. Just to the left of the airport, where Columbia Turnpike intersects with Park Avenue, is where the first ground-breaking for the Route 24 interchange to Route 287 would take place. The interchange took more than a decade to build and open. Environmental conditions and wetland issues were the principle reasons for the delay. (MMU.)

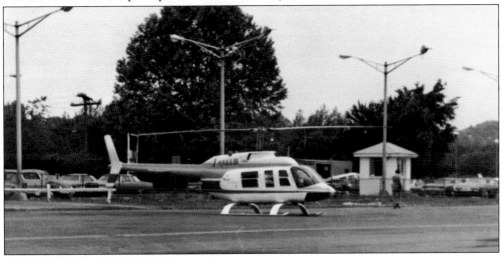

BELL 206L4 LONGRANGER IV. When the larger helicopters came along in the early 1980s, it enabled six or more corporate executives to fly directly to any number of corporate headquarters in Morris County and land at Morristown. Among the many that based helicopters at Morristown were major communications and pharmaceutical companies. Helicopters are able to make the trip to New York City in approximately 8 to 11 minutes. (MMU.)

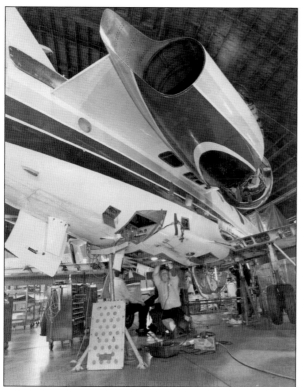

MAINTENANCE HANGAR. In the late 1980s, Falcon Jet operated a maintenance base out of Hangar 5 at MMU. The men pictured at left are Bill Vogel (right) and Jack McGee, who were employed by Jet Aviation. Here they were conducting a C check, a major maintenance effort on a Falcon 50. The airplane is jacked up off the floor so the mechanics could cycle the landing gear in and out of the wells. (Jim Gieger.)

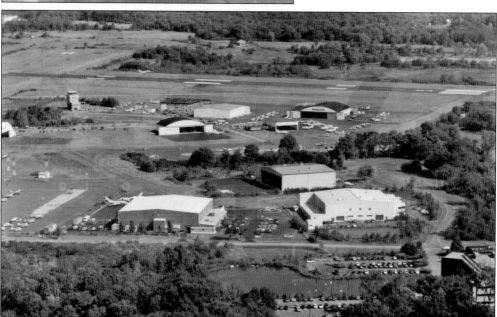

AERIAL VIEW. From the late 1970s into the 1980s, Morristown Airport was operating under a growing deficit. In January 1980, Mayor Donald Cresitello predicted the deficit would increase some $50,000 over the previous year's $150,000. This caused Cresitello to propose leasing the airport to a private firm that would manage the airport and pay off more than $2 million in outstanding bonds. (MMU.)

Three

RAPID GROWTH
1991–2010

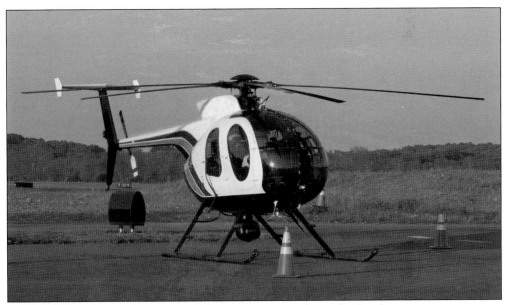

HUGHES 369D. Since many parts of New Jersey are mostly rural, a local power company uses a helicopter such as this Hughes 369D to perform aerial inspections of overhead transmission lines in northern New Jersey. The pod on the bottom of the fuselage contains a camera to record the condition of the power lines. (Darren Large.)

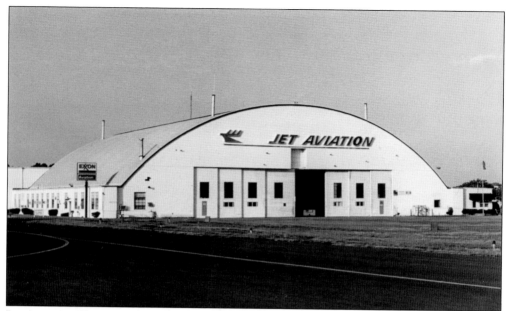

JET AVIATION HANGAR. This is the former Continental Can Company hangar. When Jet Aviation moved out, Lynton Jet Centre moved in. In 1997, Hanover Township moved to overturn the airport's tax-exempt status on several structures, including hangars, tie-down areas, runways, the tower, and the administration building. The airport is on publicly owned land and receives funds from the federal government. Ultimately the move was unsuccessful since publicly owned land cannot be taxed. (Jim Gieger.)

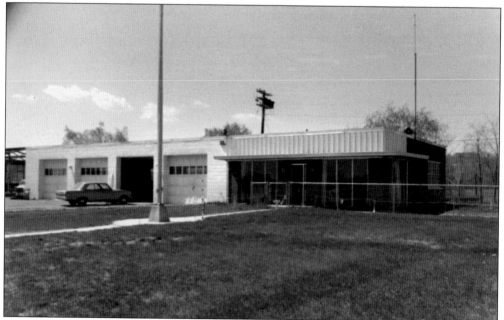

AIRPORT CONTINUES TO GROW. This is the original operations building after it closed in 1996 and just before it was torn down. The operations building was torn down to make way for the Lucent Technologies Hangar 16, Hangar 17, and the customs ramp. The new administration building replaced this one. (MMU.)

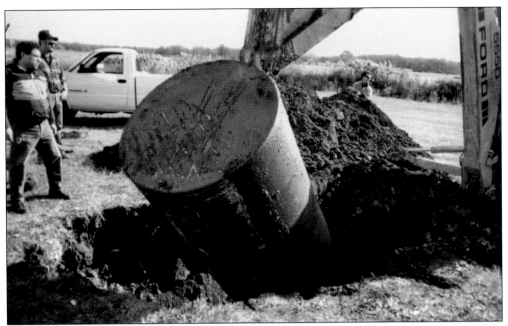

Unearthing Buried Fuel Tank. In 1990, while breaking ground for the Lucent Technologies hangar, workers discovered eight buried fuel tanks. Most contained jet fuel, but at least one contained gasoline, triggering speculation that it may have been installed soon after the airport became active after World War II. The tanks were removed safely, along with any contaminated soil. (MMU.)

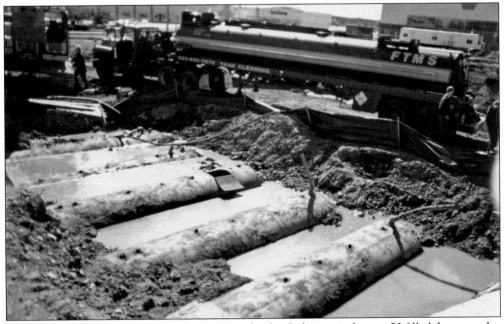

Buried Fuel Tanks. Approximately 1,000 yards of soil, the equivalent to 50 filled dump trucks, was excavated from the site of the underground tanks. There was no groundwater contamination or other health threat, according to health officials. The contaminated soil was disposed of in accordance with Environmental Protection Agency (EPA) guidelines. As part of the cleanup, monitoring wells were installed. (MMU.)

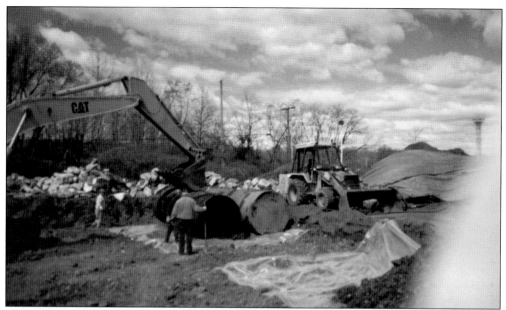

UNDERGROUND TANK REMOVAL. Workmen are seen here helping to remove two of the tanks. The tanks were pumped out before they were extracted from the ground. The tarpaulin in the rear covers the soil already removed, and the plastic sheets in the foreground were used to prevent any residual fuel from damaging the soil. (MMU.)

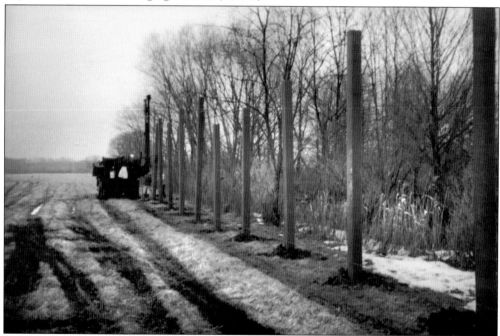

DEER FENCING. In the 1990s, MMU experienced several airplane-deer strikes. As a result, the FAA provided a grant to install a deer fence around part of the airport. This picture shows the first stage of deer fencing being placed along the approach of runway 23. This section of fence connects to a cattle grate that runs across the approach end of runway 23 and connects to a 14-foot fence on the other side. (MMU.)

LINE OF SIGHT OBSTRUCTIONS. This picture shows obstruction removal along the MALSR (Medium Approach Lighting System with Rails) road. These obstructions impact a 200-foot clear area that must be maintained around the lighting system to protect their visibility. This type of work must be done on an annual basis to keep the area clear. (MMU.)

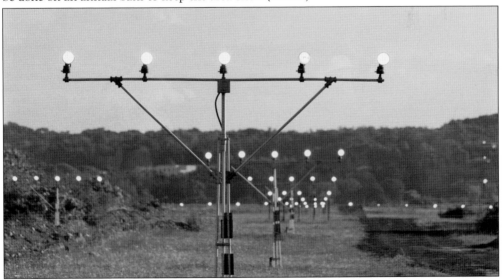

MALSR. This Medium Approach Lighting System was installed on the approach end of an airport runway and consists of a series of light bars, strobe lights, or a combination of the two that extends outward from the runway end. At small airports, the pilot switches the runway lights on via radio. The approach lights at Morristown are controlled by the air traffic control tower when the tower is open. (Darren Large.)

EARLY OPERATIONS BUILDING. New York Airways operated helicopter service out of this building for many years. The company operated Sikorsky S-61s for passengers going from MMU to Newark, Kennedy, and LaGuardia Airports. Passengers could check their bags at MMU and fly to any one of the other airports. The U.S. Customs building is sitting near where this structure was. (MMU.)

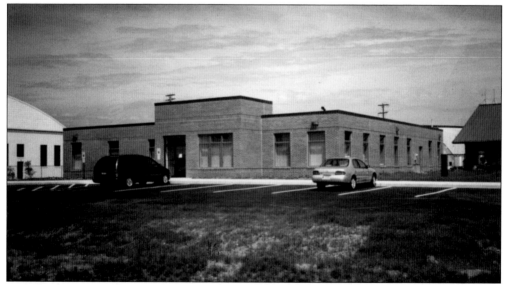

DM AIRPORTS, LTD., BUILDING. Morristown Airport is under a 99-year lease to a private company, DM Airports, Ltd. The airport-as-enterprise paradigm considers an airport to be an entrepreneurial business, and its objective is to identify and meet the needs of a diverse clientele, including not only airlines and private pilots, but also passengers, meters and greeters, airport staff, airport neighbors, and airport tenants. (MMU.)

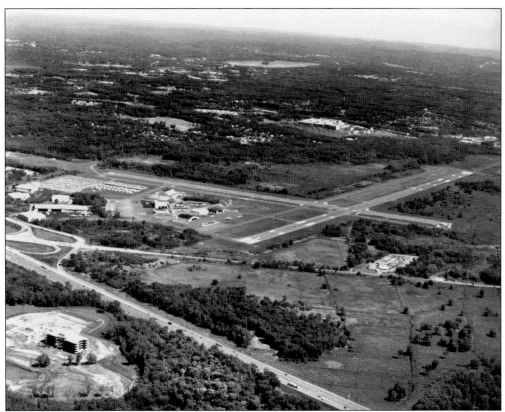

LOOKING NORTHWEST. The lower left shows the completed Route 24 bypass interchange at the Columbia Turnpike. The Department of Transportation condemned 7 acres necessary for the interchange and paid Morristown $1.4 million for the land. Just above it and intersecting it on the left is the Columbia Turnpike, with runway 5 ending just before the turnpike. (Carl Laskiewicz.)

GENERAL AVIATION. General aviation users at privately operated Morristown Municipal Airport have been mostly positive about improvements in pavement and services at the airport under private management. Of the 46 airports in the state of New Jersey, Morristown is one of 28 that are publicly owned and privately operated. Morristown owns the airport, but DM Airports, Ltd., has been operating it since 1982. (MMU.)

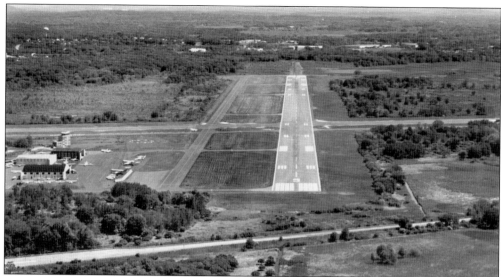

APPROACH TO RUNWAY 5, 1990S. The extension of runway 23 was completed in 1971–1972. The extension begins from the first set of dashed touchdown markings at the far end of the runway and ends at the end of MALSR Road in the distance. The 5-23 runway extension and taxiway improvements required the moving of 400,000 tons of mud, sand, and dirt. The project was funded at $2.3 million. (Carl Laskiewicz.)

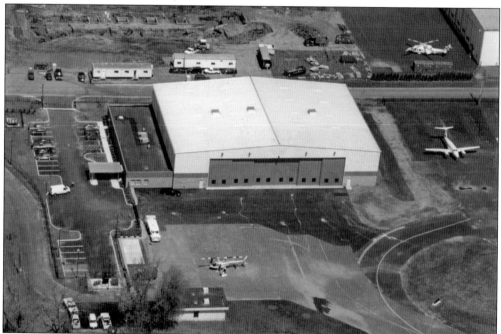

AMERICAN HOME PRODUCTS HANGAR. Newly completed Hangar 16 was built on top of the old taxiway Charlie. Near the top of the picture, Hangar 17 work is visible, and on the bottom is the U.S. Customs facility. The old airport administration building was removed to make way for Customs Road. The large paved area that compromises the customs ramp and the Hangar 16 apron is where DM Airports, Ltd., operated a ramp for transient aircraft from 1982 until the development of the new hangars. (MMU.)

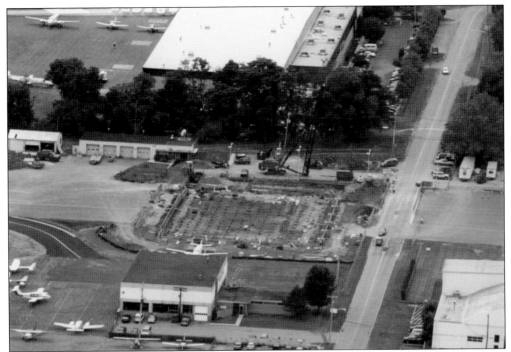

AMERICAN HOME PRODUCTS IN HANGAR 16. The pilings for the American Home Products hangar were driven in 15 consecutive rows across the site for support. This hangar was built on top of the old taxiway Charlie, which ran through the center of the airport. The former airport administration building is to the left of the hangar site. Today the U.S. Customs office shares its apron with this hangar. (MMU.)

RUNWAY CLOSED. This is an example of a runway-closure marker used on runway 23 between November 1991 and December 1992. Note the sandbags used to hold it in position. This was used until it was replaced by a more solid fabric "X." In 2009, the airport received a grant from the New Jersey Department of Transportation (NJDOT) that provided for the purchase of lit Xs that are now used to close a runway. (MMU.)

RUNWAY-CLOSED MARKER. This runway-closed marker is used to effectively warn pilots of closed runways and taxiways. The trailer-mounted, diesel-powered unit features 20 spotlights that form an illuminated 28-by-28-foot "X" visible up to 25 miles away. (Darren Large.)

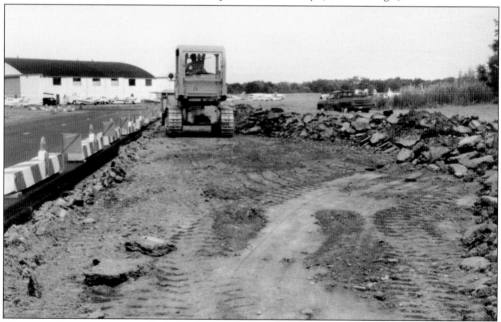

TAXIWAY REHABILITATION, SEPTEMBER 1990. As part of regular maintenance at Morristown Airport, taxiway Delta was rehabilitated in 1990 through an FAA airport improvement grant. Pavement on an airport will generally last approximately 20 years with yearly maintenance. In 2009, the airport received a grant through the American Recovery and Reinvestment Act (ARRA) to rehabilitate four taxiways, including taxiway Delta. (MMU.)

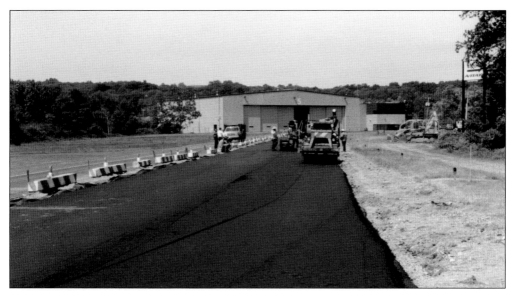

TAXIWAY DELTA CONSTRUCTION, 1990. The taxiway Delta work was unique in that workers had to split the taxiway in half in order to pave it. Taxiway Delta is the only access point for aircraft located in hangars on that side of the field. Since there was not space available to accommodate all the aircraft being moved out of the hangars, the airport had to split the taxiway in half and tow aircraft down the paved side while work on the other side proceeded. (MMU.)

TAXIWAY DELTA CONSTRUCTION, 2009. The airport received an American Recovery and Reinvestment Act (ARRA) grant in 2009. This grant provided money for the rehabilitation of taxiways Charlie, Lima, Delta, and Mike. Delta and Mike had previously been completed in the early 1990s, as pictured above. After meeting its useful life of 20 years, those sections of pavement needed to be rehabilitated. Aircraft located in hangars along taxiways Delta and Mike have only one way in and one way out. (Darren Large.)

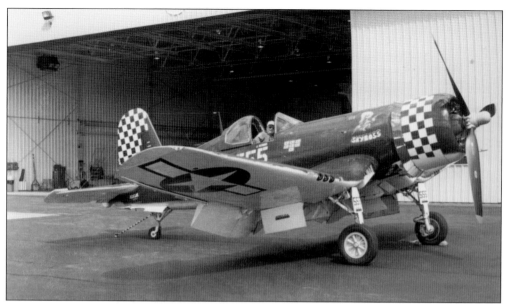

NAVY **F4-U** CORSAIR. When this FU-4 Corsair showed up at MMU, it was NX83JC, meaning it was flying under an experimental registration. Built in 1940, it was a carrier-based aircraft that remained operational from 1942 through the Korean War exclusively by the U.S. Marines. Note the deployed tail hook. The gull-shaped wing allowed a larger propeller. The pilot, Dan Dameo, is a corporate pilot based at MMU. The airplane is currently based at the American Airpower Museum in Farmingdale, New York. (Robert Vanderhoof.)

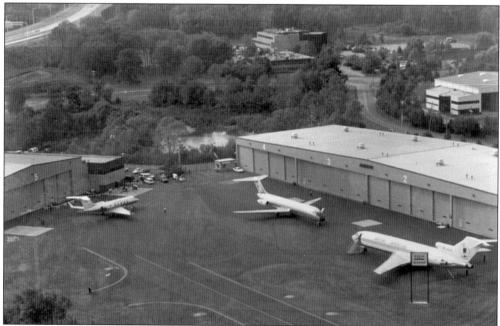

MMU, c. 1992. Pres. George H. W. Bush landed at Morristown during his campaign in a VC-9C jet, seen in the center in front of Hangar 9. To its left is air force Gulfstream IV, and to its right is a Boeing 727 belonging to Airline Americas. In the upper left is Route 24, finished but not yet open to traffic. (Jose Cruz.)

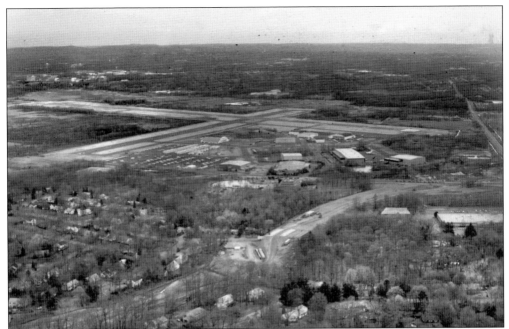

CONSTRUCTION OF ROUTE 24. In this mid-1990s aerial photograph, the Columbia Turnpike is on the right. This is a photograph of Morristown Municipal Airport during the wintertime, and construction of Route 24 is taking place in the lower center. Issues of wetlands in the area delayed the construction. (MMU.)

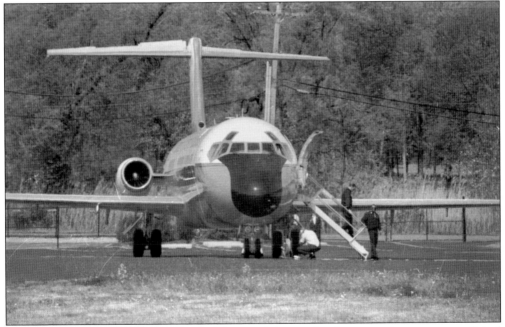

SEN. AL GORE DEPLANING. Morristown Municipal Airport has long served as a stop on political campaigns. In 1992, then senator Al Gore made Morristown a stop on his 1992 campaign for vice president. The future vice president is deplaning from a VC-9C jet, preceded by a Secret Service agent. (MMU.)

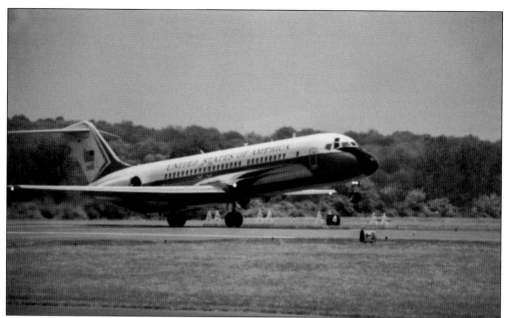

VC-9C Landing. The VC-9C is the military version of the civilian Douglas DC-9-30 series. It is used as a VIP transport by the U.S. Air Force to transport cabinet members and other high-ranking officials such as the vice president. It is seen here landing in 1992 with vice presidential candidate Al Gore aboard. (MMU.)

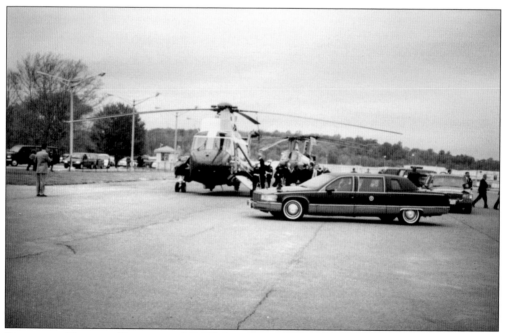

President Clinton Departing MMU. In every presidential election cycle, candidates and presidents converge on Morristown Municipal Airport, all seeking the "Small Town USA" setting. Even though New Jersey's record of voting is predominantly Democratic, the incumbent U.S. president Bill Clinton did not take the state for granted. (MMU.)

SNOWSTORM. On February 11, 1994, a state of emergency was declared when a 10-inch snowstorm hit New Jersey, closing all the commercial airports for at least part of the day. Morristown Municipal Airport remained open for takeoffs, with 15 aircraft departing. Maintenance crews at MMU worked more than 40 hours to keep the runways clear. (Darren Large.)

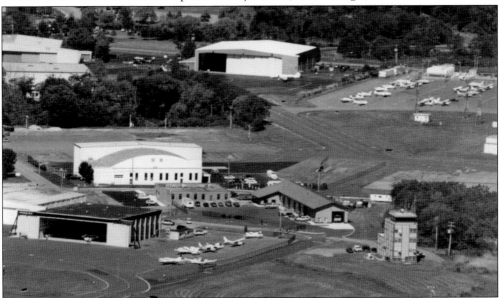

NEW MAINTENANCE AND OPERATIONS BUILDING, C. 1997. In order to make room for Hangars 16 and 17, the airport administration and maintenance buildings had to be moved from taxiway Charlie. In this picture, one can see the completed maintenance building to the rear of the tower. Also visible is the newly completed administration building to the left. Note the open bay door at the end of the maintenance building and the Walters crash truck in the bay. (MMU.)

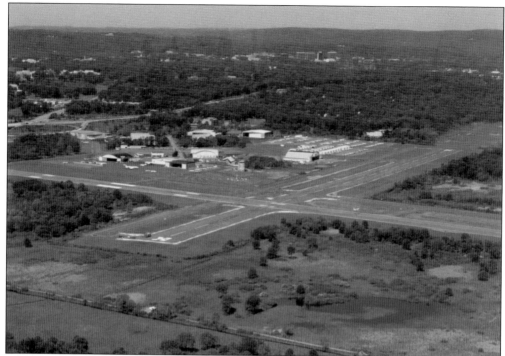

MMU, C. 1997. Looking west in the distance near the top and to the right are the Washington Towers in Morristown, the tallest buildings in the area. The old administration building is still standing. Runway 13-31 is closed, and maintenance work is underway. (MMU.)

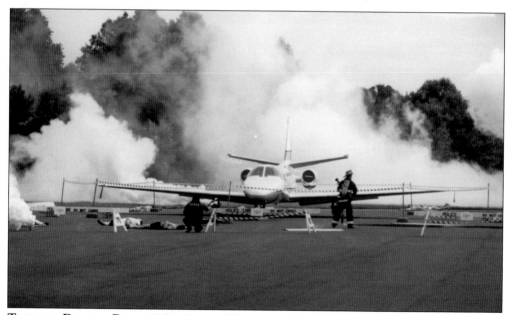

TRIENNIAL DISASTER DRILL, 1994. As part of the triennial drill, firefighters from local municipalities will come to MMU and run through aircraft-accident scenarios. This scenario involved a simulated bomb aboard a hijacked Cessna Citation S2. This drill focused on the results of the bomb blast, bringing additional types of injuries and situations into the training program. (MMU.)

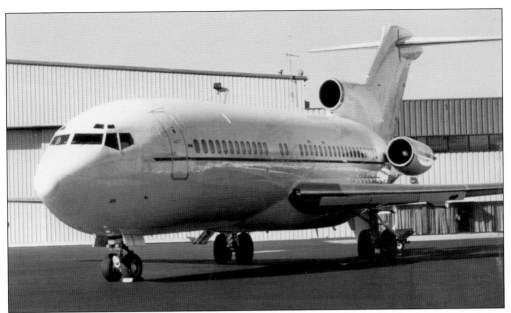

BOEING 727. This is an air force C-22, the military version of the Boeing 727. The C-22's unique arrangement of leading-edge devices and trailing-edge flaps permit lower approach speeds, thus allowing it to operate from runways such as MMU's. This aircraft was present for President Clinton's VIP visit to MMU. (MMU.)

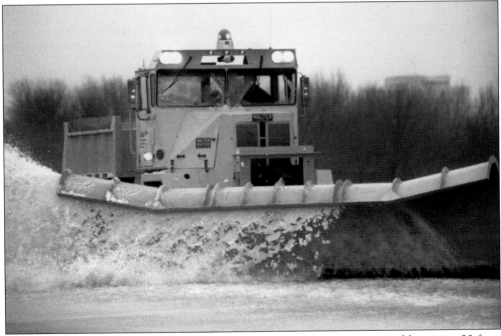

PLOWING A RUNWAY. This huge snowplow is designed to clear runways quickly using a 20-foot-wide flow blade. Starting from the numbers on the runway, five trucks all proceed in right echelon formations. They are staggered with edge-of-plow to edge-of-plow, almost like one side of a triangle. The truck can throw snow 150 feet away at 2,500 tons of snow an hour. The truck driver is Erik Hansen. (Darren Large.)

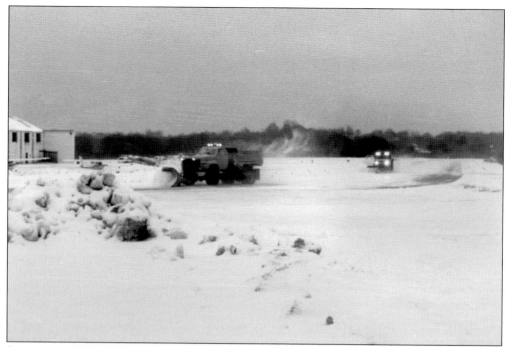

Snowplow 1995–1996 Storms. Morristown Airport is seen here in the teeth of one of New Jersey's worst blizzards. The total accumulation of snow at Morristown for the winter of 1995 and 1996 was 76 inches. For a time, all air traffic in the metropolitan area was grounded, and the airports were closed down, with the exception of Teterboro. The storm also claimed Washington Dulles, Washington National, Baltimore-Washington International, Philadelphia International, and Boston's Logan International Airports. (MMU.)

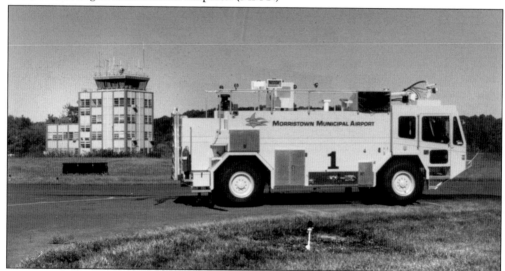

Tower and Truck. In 1996, MMU received the first aircraft rescue and firefighting vehicle (ARFF) that could be operated by one person. It had the capacity to apply water, foam, or dry chemicals to a burning aircraft. In addition, it is equipped with searchlights for nighttime firefighting, the "Jaws of Life," and other tools for prying open wreckage. The cost of $325,000 was paid in part by federal grants and via a fuel surcharge for tenants and users of the airport. (MMU.)

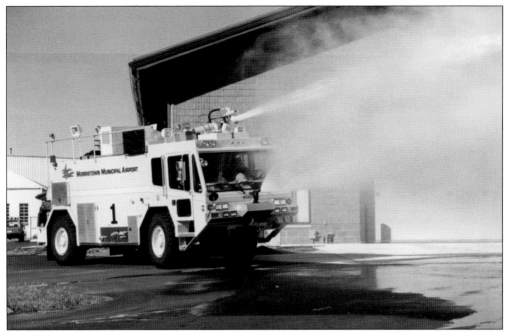

RAPID-INTERVENTION VEHICLE. The Aircraft Rescue Station, operating 24-hours a day, provides immediate response to an aircraft emergency. The service personnel operates a Walter four-wheel Rapid Intervention Vehicle (RIV), which has the capacity to hold 1,500 gallons of water, 180 gallons of foam, and 500 pounds of dry chemical agent. The vehicle is equipped with a roof and bumper turret. In December 2008, it was replaced by an Oshkosh Striker. (MMU.)

1996 CAKE. In 1996, DM Airports, Ltd., opened the new Maintenance and Aircraft Rescue Fire Fighting (ARFF) Building at MMU. Many local politicians and members of the community were invited to the airport for a ribbon-cutting ceremony. This cake was served as part of the grand-opening ceremony for the new ARFF Department. (MMU.)

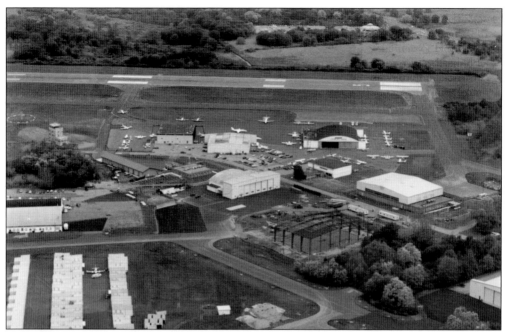

STEEL WORK LUCENT HANGAR This is a photograph of the Hangar 17 superstructure. Both Hangars 16 and 17 were built on the old Charlie taxiway that previously crossed the airport entrance road. Hangars 16 and 17 were the first major developments constructed on the airport in almost 10 years. Their completion set up the split halves of the airport that exists today. (MMU)

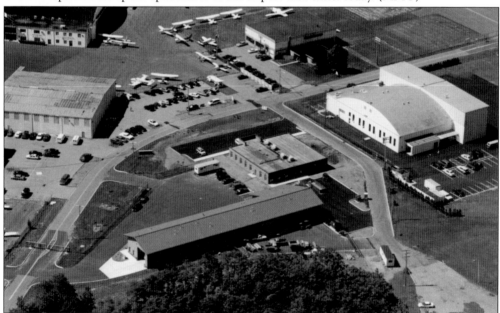

COMPLETED ADMINISTRATION BUILDING. The maintenance building, which is the long structure on the bottom, was completed before the administration building. The long building housing maintenance, operations, and the ARFF department is located on the end. Today there is another structure behind that one, and it houses the operations department. The current administration building is in the center of this photograph. (MMU.)

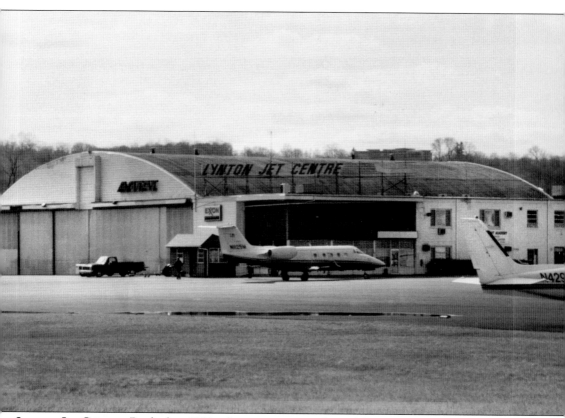

Lynton Jet Centre. By the late 1960s, the airport was in the middle of residential development that was exploding by leaps and bounds. Jet engines had become a major issue, and the issue had gone to the courts. A March 1970 ruling limited jet flights in and out of MMU to between 7:00 a.m. and 9:00 p.m. on weekdays and between 1:00 p.m. and 3:00 p.m. on Sundays. In November 1973, a superior court judge removed the earlier ruling restricting jet flights based on a supreme court decision regarding the airport in Burbank, California. (MMU.)

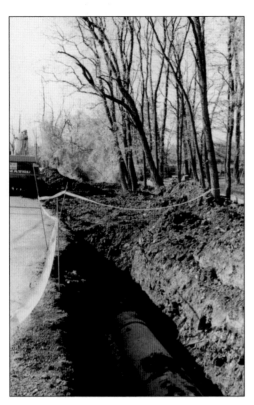

STORM WATER PIPE UNDER TOWER ROAD. When the Route 24 bypass was under construction, some water and sewer lines had to be removed, diverted, or relocated. This storm water runoff line was installed when workers had to adjust Airport Road because of Route 24 development. Additional care had to be employed, since much of the airport stands on wetlands. (MMU.)

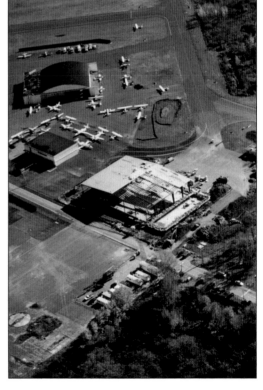

AERIAL OF CONSTRUCTION. This image shows Hangar 16 being built on the former taxiway Charlie and the DM Airports, Ltd., aircraft ramp. The pavement to the left of that is where Hangar 17 would be built. The Northeast Airways hangar was also demolished to make way for Signature Flight Support Hangar 1, which would be constructed later. (MMU.)

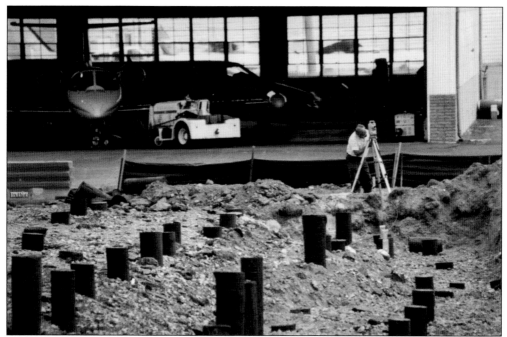

PILINGS FOR LUCENT HANGAR. In 1998, Lucent Technologies became a tenant of MMU. Because of the unstable, meadow-like soil found on the airport, many hangar developers had to drive piles into the ground to increase support for structures. This structure, when completed, yielded 40,000 feet of hangar space and 17,000 feet of office space. (MMU.)

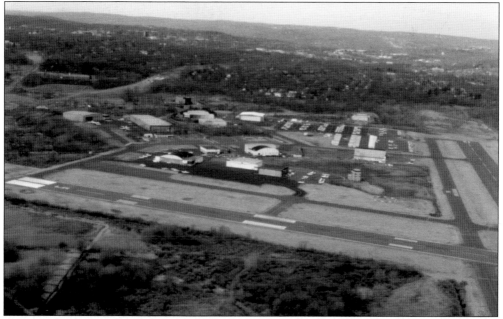

TAXIWAY PROJECTS. In 1998, MMU began rehabilitation work on five of its 12 taxiways, the first project of its kind since they were built in the late 1960s and early 1970s. The FAA awarded a grant of more than $844,700 for the reconstruction of the taxiways and the installation of a gate similar to those at railroad crossings where Airport Road crosses one taxiway. (Carl Laskiewicz.)

COLUMBIA MEADOWS UNDER WATER. According to the National Oceanic and Atmospheric Administration (NOAA), Morristown received 9.4 inches of rain during the 1999 Hurricane Floyd. Morristown Airport Tower is in the background, and the meadows in the foreground are flooded. It took several days for the airport to become fully operational. MMU tends to flood during major rain events. Maintenance personnel in the boat are Erik Hansen, Scott Peterson, and Steve Steinson. (MMU.)

HURRICANE FLOYD AT TETERBORO AIRPORT. When Hurricane Floyd hit Teterboro Airport, it left almost 14 inches of water on the airport and in the surrounding community. Teterboro was shut down until it could be drained, and much of its traffic was diverted to Morristown. Power was out in many areas of New Jersey for more than a week, and dozens of aircraft suffered serious damage from the floodwaters. (Allisandra Joy Fairclough/NJAHOF.)

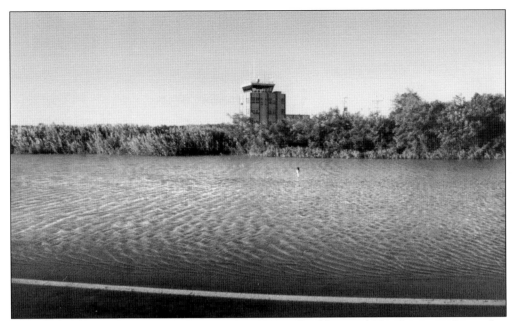

HURRICANE FLOYD FLOODS THE AIRPORT. Hurricane Floyd battered New Jersey on September 16, 1999, and brought with it torrential and, in some areas, unprecedented and record-breaking rains and damaging winds. The hurricane went down in history as the greatest natural disaster to ever affect the state of New Jersey to date. Doppler storm totals estimated 10 to 12 inches covered much of Morris County and adjacent areas in Essex, Passaic, and Union Counties. (MMU.)

FUEL FARM ARCHITECTURAL DRAWING. This architectural drawing showed what the fuel farm would look like either after a renovation or when it was moved to a new location. The fuel farm was moved (on paper) at one point and then was redone at the new location at a later point. Two more tanks were added to the original four. (MMU.)

FUEL FARM HOOKUP. This is a photograph of the fuel farm before the two additional tanks were added. The worker is handling the hose that connects to the fuel trucks that deliver the fuel to the aircraft. It appears that he would be connecting it to a truck, but the bonding cable is not hooked up yet, which is the first step. (MMU.)

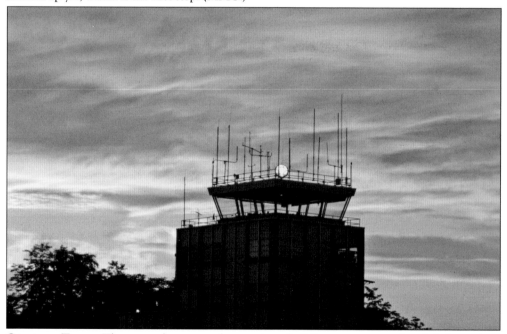

CONTROL TOWER The control tower and operations building were opened and dedicated on October 27, 1961. The control tower took advantage of the $260,000 it was awarded in federal funds, and the staff expected the tower to be utilized 24 hours a day. The airport does not have radar, and the current tower operations are from 6:45 a.m. to 10:30 p.m. (Gary Evenson.)

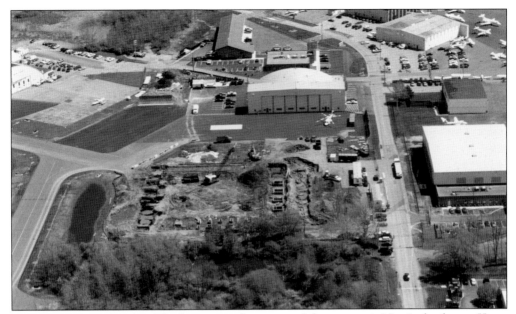

PILE DRIVING AT LUCENT. The hangar in the center of the picture is No. 6, the former Keyes Fibre hangar. To the right and directly across the road is the Northeast Airways hangar. Below that is Hangar 16. Hangars 16 and 17, which are shown under development in the picture, were built on top of taxiway Charlie. The northeast hangar and the two above were removed to make way for the new Hangar 1. (MMU.)

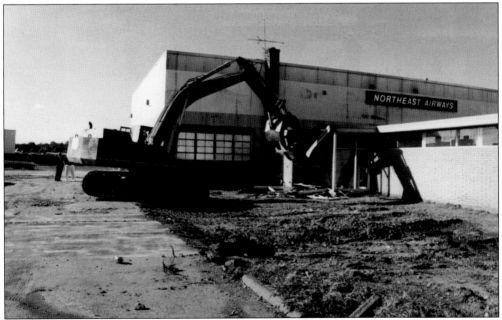

SIGNATURE FLIGHT-SUPPORT CONSTRUCTION, 2001. In October 2001, Signature Flight Support, the airport's only fixed-base operation (FBO), embarked on a major building project. Signature razed three existing structures and replaced them with one giant 90,000-square-foot building that provided almost one-third more space than the three structures it replaced. The demolition of the Northeast Airways hangar is underway to make room for Hangar 1. (MMU.)

SITE OF THE SIGNATURE FLIGHT-SUPPORT HANGAR. This is where the Northeast Airways hangar originally sat. That area was cleared out for the development of Hangar 1. The other hangars to the left would all be knocked down also. The airport administration building is on the right. (MMU.)

SECURITY FENCING AROUND TOWER. With all the new security measures in commercial air travel after September 11, 2001, general aviation had to quickly adapt and introduce new security measures. The operational areas of the airport were fenced in and additional fencing of individual buildings began. Today clearance is needed to be in all areas of the airport, and badges are required to be worn when anywhere on the airfield. (MMU.)

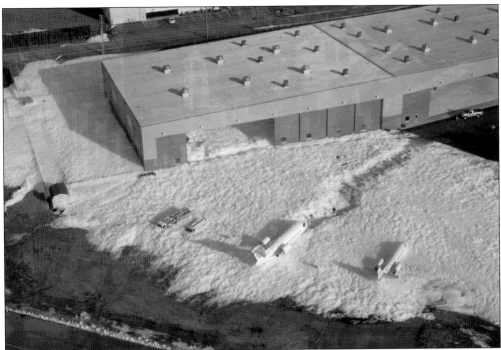

FOAM DISCHARGE In December 2003, the foam fire-suppression system at the Signature Flight Support hangar was discharged. In a matter of 30 seconds, the entire hangar bay was filled with foam. The foam caused the doors to malfunction and open, pouring a huge wall of foam onto the ramp. In this picture one can see an employee using a backpack blower to blow the foam away so he could reach the aircraft. The foam on the ramp was 11 feet deep and covered the ARFF truck. (Both, MMU.)

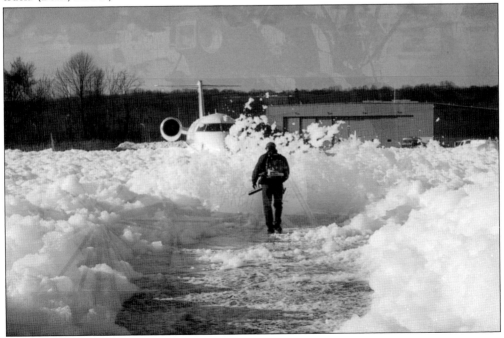

RUNWAY CRACKS. Dozens of aircraft, varying from a few thousand pounds to 50,000 to 60,000 pounds roll over the taxiways daily. The grooving is purposely cut into the runway for drainage to avoid hydroplaning. The freeze-thaw cycle in winter and the fact that the airport is built on meadowlands has caused the taxiways to shift somewhat. Runway touchdown markings, center lines, and numbers are repainted annually due to rubber buildup from tires and scraping from plows during winter operations. (Darren Large.)

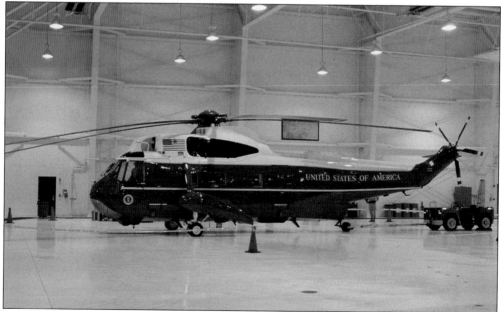

MARINE ONE. During one presidential visit to the New York City area, *Marine One* was housed at MMU for easy access to the metropolitan area. *Marine One* is off-limits to even airport personnel. The cones and tape are meant to act as boundaries, since no one is allowed past the tip of the rotor blades, and a marine guard can be seen behind the helicopter to enforce that rule. (Darren Large.)

DRAINAGE SWALE. The Columbia Meadows have always been a constant source of excess water and poor runoff or ground absorbance. This swale is a broad, vegetated channel used for the movement and temporary storage of water runoff. Swales can be effective alternatives to enclosed storm drains and lined channels, where their only function is to rapidly move runoff from a developed site. (MMU.)

COLUMBIA MEADOWS. The wild, untouched appearance of the meadows off the Columbia Turnpike gives little hint that the third busiest airport in New Jersey lies beyond. Morristown Municipal Airport is a general aviation reliever airport, which in the past handled 220,000 or more flights a year, mostly for corporate and private clients. It is designed to ease the pressure on the large metropolitan airports such as Newark Liberty International, JFK, and LaGuardia by receiving business flights. (MMU.)

FIXING A LIGHT. As part of regular maintenance on an airport, an employee removes the incandescent bulb from a taxiway light. In recent years, the airport has begun to transition to LED light fixtures to save money on electricity and bulb replacement. LED lights also last longer than the older incandescent lights. (MMU.)

DOUGLAS DC-9. This DC-9 was owned by Steve Wynn, the famous casino owner. He owned the Golden Nugget, Bellagio Casino, and other casinos in Atlantic City and Las Vegas. He had business in Atlantic City, and a helicopter flew him up from there to Morristown, where he departed after his meetings. (MMU.)

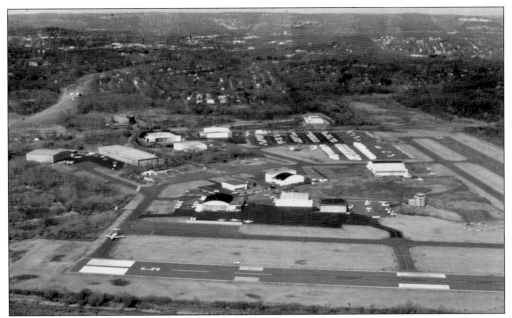

RUNWAYS REPAINTED, 2002. The main runway was originally 4-22, but now it is 5-23. Runway 12-30 was renumbered in 2002 to 13-31. Runway 5-23 had originally been 4-22 but was renumbered sometime in the 1960s or early 1970s. Runway numbers are based on a compass heading, and as the magnetic field changes a drift occurs. When the heading no longer matches up with the runway numbers, the numbers are changed. (Carl Laskiewicz.)

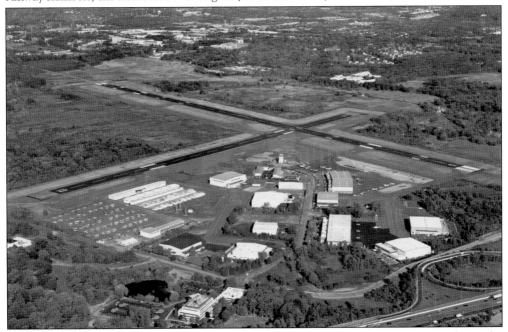

MMU, c. 2004. In the lower left of this photograph is an office complex. It stands on the approximate location of the Normandy Water Works water tanks seen in the image at the bottom of page 17. Route 24 is also on the bottom of the picture. What is significant in this photograph is the dry land just above the runway intersection. (Carl Laskiewicz.)

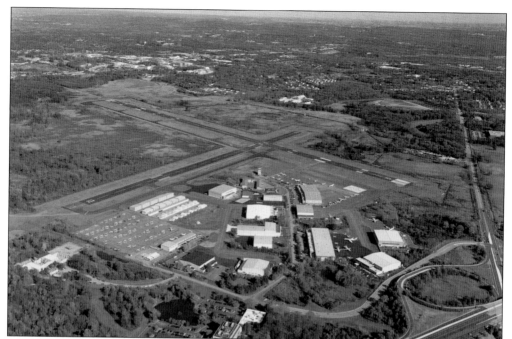

MMU, c. 2007. Taken from approximately the same angle in the fall of 2007, this photograph shows the same area above the runway intersection now has a small body of water. Although a welcome sight for migrating birds, the wetlands can cause a safety hazard for aircraft using the facility. MMU has an extensive wildlife management program. (Carl Laskiewicz.)

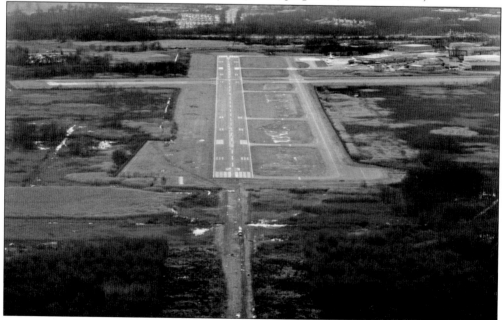

APPROACH TO RUNWAY 23. On the right in the distance is Morristown Municipal Airport. Beyond it is the Columbia Turnpike. Taxiway Hotel on the right leads to taxiway Alpha, which parallels the runway, followed by taxiway Golf and Foxtrot. In the center below the runway is MALSR Road. In the upper right-hand corner are the airport buildings. (Darren Large.)

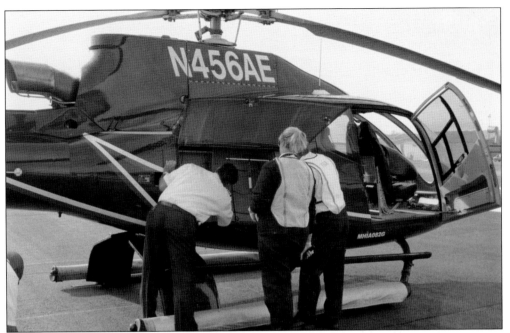

TSA SCREENING. During the Republican Convention in New York City in 2004, the Transportation Security Administration (TSA) required all helicopter traffic bound for New York City to land at Morristown Municipal Airport for a security screening. Here personnel on board and baggage are screened. An explosives-sniffing dog also examined the craft. (Carl Laskiewicz.)

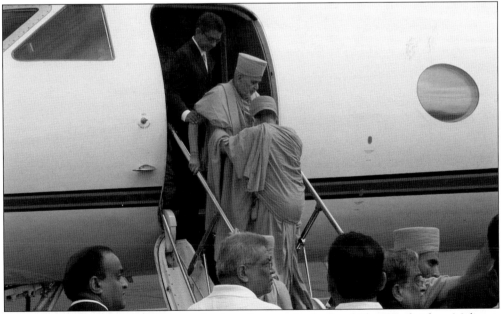

LORD SHRI HARIKRISHNA MAHARAJ. In this photograph, the Lord Shri Harikrishna Maharaj, Pramukh Swami Maharaj is shown arriving at the U.S. customs ramp at Morristown Airport. The followers of Pramukh Swami Maharaj believe that he is the fifth spiritual successor of the Bochanwasi Akshar Purushottam Sanstha. Presently Pramukh Swami is the leader of Bochasanwasi Shri Akshar Purushottam Sanstha. (Darren Large.)

BOEING BUSINESS JET (BBJ). This Boeing BBJ is one of the larger visitors to Morristown Municipal Airport. Due to the length of the runway—6,000 feet—the airport is able to accommodate the variant of the Boeing 737 aircraft. Since Teterboro banned these from flying into its airport due to community noise complaints, MMU is usually the only airport in the area to receive the BBJs. (Darren Large.)

LANDING GEAR PROBLEM. Cessna 172RG reported that it was unable to retract the left main gear. The pilot flew around for approximately an hour in an attempt to free the gear. After unsuccessful attempts, he decided to make an emergency landing. ARFF and other mutual-aid organizations were standing by waiting for the landing. (Darren Large.)

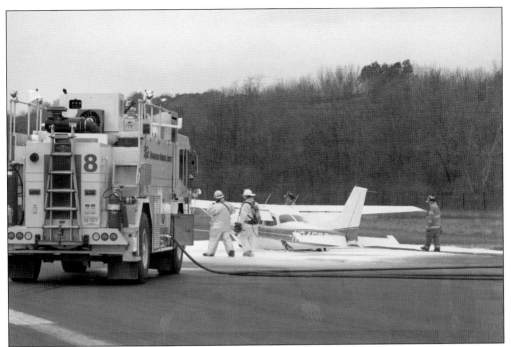

SAFE LANDING. Following touchdown, the ARFF department sprayed foam on the aircraft as a precaution. This was a training flight with a certified flight instructor and student pilot aboard. Both walked away without injuries. The aircraft was then lifted off the runway by a tow truck crane, and the gear was lowered. It was towed to the maintenance shop, repaired, and is still flying. (Darren Large.)

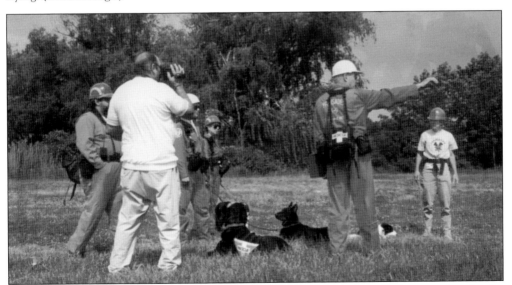

RESCUE DOGS. During a disaster drill, rescue dogs are waiting to be called into action. In the event of a real accident, these specially trained dogs will rush into the wreckage with no concerns for their own welfare and pull out victims, some dead and some still alive. They do this time and time again. There are different types of breeds who make better rescue dogs than others, such as German shepherds and Labradors, seen here. (MMU.)

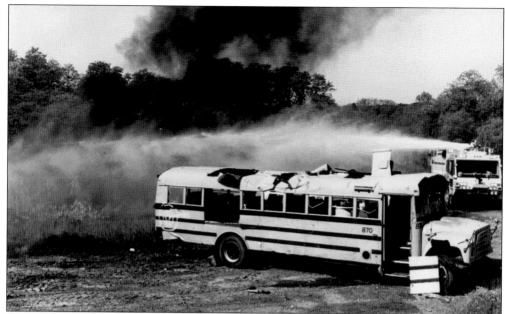

IMPROVED FIREFIGHTING TECHNIQUES. As a result of a fatal corporate jet crash in the summer of 1988, officials developed an on-site disaster plan that called for on-site firefighting equipment and trained personnel. Until then, the Morristown Fire Department, located 2.9 miles away, was the first responder to all accidents. Morris Township, located 1.7 miles away, was the backup. (MMU.)

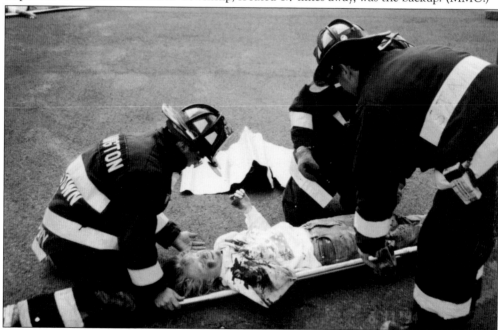

ACCIDENT-READINESS DRILL. All the "victims" are local volunteers who are trained on how to act in a particular role. Made-up with simulated catastrophic injuries that include amputations, deafness, blinded, and disoriented, the volunteers are taught to respond in various ways to the rescuers. After triaging the victims, the seriously injured are transported to Morristown Memorial Hospital, which is a level one trauma center. (MMU.)

A JET TAKEOFF IN A SNOWSTORM. This aircraft was coming off the newly completed deicing pad. Today there is no doubt that Morristown Municipal Airport benefits the surrounding communities. The economic output of $243.6 million, plus the existing value of the airport itself of $167.1 million, totals $410.7 million. The airport supports a total of 1,158 jobs. The airport also generates more than $13.3 million in state and local taxes. (Darren Large.)

LIVE BURN. This live burn was conducted during the triennial drill at MMU in 2008. The firefighter pictured is Roy Kauffman, and he was a designated safety officer monitoring the drill. During this drill, Kauffman was overseeing a simulated fuel fire on Runway 13-31 near the aircraft trainer that is being blocked by the flames. (Darren Large.)

AROUND-THE-WORLD RECORD. Jared Isaacman, at 26 years old, along with copilots Doug Demko and Shaun Leach, departed MMU on March 28, 2008, and flew the 23,000-mile trip in a Cessna Citation CJ2 to raise money for the Make-a-Wish Foundation. Isaacman and his crew raised more than $45,000 for the foundation. (Darren Large.)

ROUND-THE-WORLD FLIGHT. At 8:44 a.m. on April 15, 2009, Isaacman landed at MMU, breaking an around-the-world speed record for light jets that had lasted for 18 years. The old record for a light jet was 82 hours. Isaacman shaved about 20 hours off the old record. From left to right are Doug Demko, Shaun Leach, and Jared Isaacman. (Darren Large.)

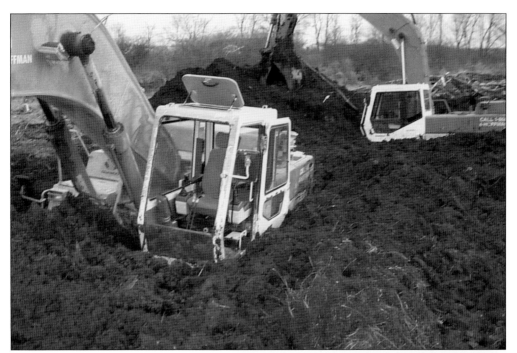

SOFT GROUND. Morristown Municipal Airport sits on top of a meadowland and an underground aquifer. The ground sinks in places, and the soil can trap machinery. Here workmen had been removing obstructions during an airport project when the machine sunk into the soil. A second machine was brought in to pull the first out and it, too, sunk. A third machine eventually rescued the other vehicles. (Darren Large.)

BADGING. After September 11, 2001, airport management made a decision to implement an extensive security plan that required every person on airport property to wear a badge. MMU was one of the first, and one of the few, general aviation airports that had all its tenants carrying access badges. Shown at right are Peter Gilchrist, operations manager, having his badge photograph taken by Aaron Boub, operations coordinator. (Darren Large.)

HOSING DOWN A FIRE. During a triennial disaster drill, a group of firefighters sprayed water on the fire in an attempt to put it out. The flames were created from a metal pad that lies on the runway and forces propane through it like a grill. Sensors can read the amount of water that is put down on the mat, and when enough has been sprayed, the fire will go out. (Darren Large.)

AUTHOR DARREN LARGE. When author Darren Large is not working as a MMU manager of facilities and projects, he participates in the simulated disaster drills. All airport personnel, by the nature of their presence, are first responders to an accident. They are trained to respond to various emergency situations, from a crash to a minor incident. (Darren Large.)

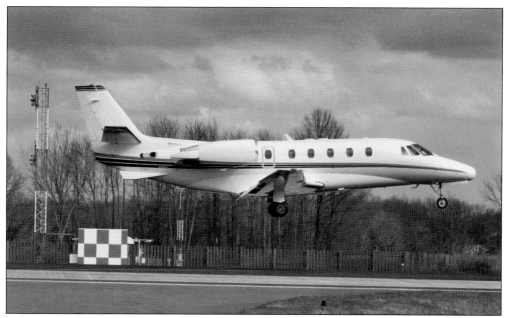

CESSNA CITATION 650. One of the more common users of MMU, this aircraft is a Cessna Citation 650 operated by NetJets. Take note of the checkered building and towers in the background. The checkered building is part of the Instrument Landing System (ILS). The large tower is the localizer and glide-slope antenna for the ILS. The smaller tower is the airport's Automated Weather Observation System (AWOS). (Darren Large.)

BRETT FAVRE. In August 2008, Brett Favre (left) signed with the New York Jets after being released by the Green Bay Packers. After arriving at MMU, Favre signed a contract with the Jets and boarded a helicopter to Giants Stadium, where he met the team and flew to Ohio for a preseason game. (Darren Large.)

Ducks in the Water. Heavy, sometimes flooding, rains in the meadows surrounding the airport often flush small creatures onto the hardtop, and they become hazards to aircraft traffic. Poor drainage conditions on the airport increase the likelihood of wildlife seeking higher ground. These wildlife conditions are dangerous to aircraft operating in and out of an airport. (MMU.)

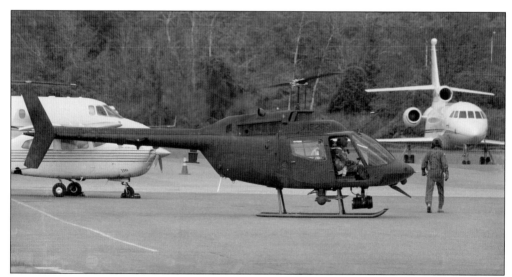

U.S. Army JetRanger. MMU, like all airports, is integral to national defense. This is an example of the many military visitors Morristown sees each year. The New Jersey State Police and aeromedical evacuation transport helicopters (Medevac) also frequently use MMU as a base station near St. Barnabus in Livingston, a national burn center, and Morristown Memorial Hospital, a level one regional trauma center. (Darren Large.)

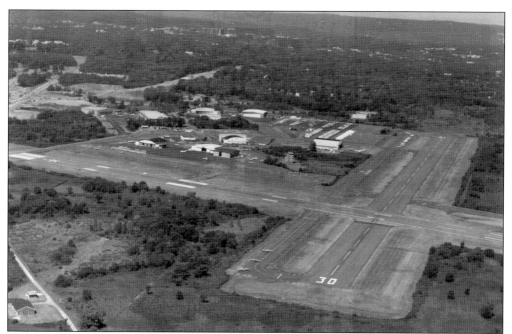

OVERHEAD RUNWAY 30. This photograph, taken around 1989, shows aircraft displaced from the west tie down and parked on taxiway Bravo. Half of the west tie down still needed to be rehabilitated. Runway 5 is closed, and Route 24 in the background left is under construction. (Carl Laskiewicz.)

TYLER DEICING TRAILER. The deicing trailer is used before a storm to coat the runway with a fine stream of liquid potassium acetate. This helps to prevent a bond from forming between the snow and the runway, which can create icy conditions. Each application costs approximately $7,000. Only noncorrosive chemicals can be used on the airport in order to protect the aircraft. Once the storm starts, airport personnel deploy a solid chemical like sodium formate or sodium acetate. (Darren Large.)

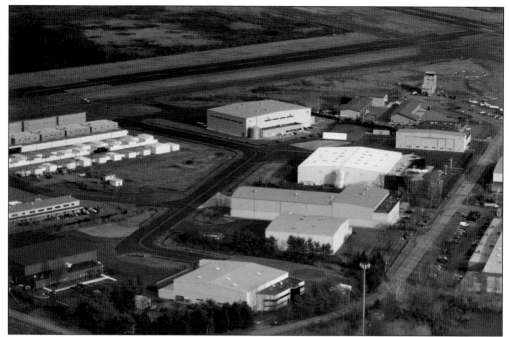

Taxiway Charlie/Lima. In 1947, the first hangars were erected at the airport, and over the years more were added. This is the Charlie/Lima side; Charlie is on top, and Lima is down the middle. Hangars in order from top to bottom are 5, 7, 17, 18, 10, 11, and 12. (Darren Large.)

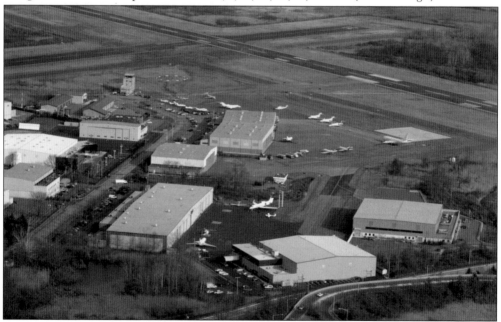

Third-Busiest Airport. Morristown ranks as the third-busiest airport in the state, with approximately 245 aircraft based at the airport. There were 143,000 takeoffs and landings in 2008. During the past two decades, it has seen rapid growth, primarily as a result of corporate traffic thanks to a number of large corporations in the area. The airport has 12 major hangars that range between 25,000 to 40,000 square feet in size and 40 smaller ones. (Darren Large.)

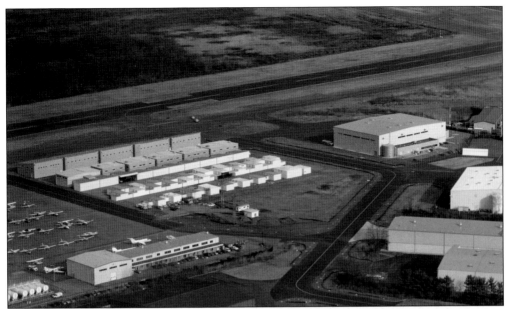

C&L Taxi-Work Stimulus. As part of the American Recovery and Reinvestment Act (ARRA) of 2009, Morristown Municipal Airport received a grant to rehabilitate taxiways Charlie, Lima, and taxilane Kilo in the west tie down area. It also involved the installation of new LED taxiway lights. This section of taxiways had been milled and overlaid previously, but the subbase had not been touched since the airport was built in the 1940s. (Darren Large.)

Cockpit View. This is a touchdown view of a Gulfstream IV arriving on Runway 5 at Morristown Airport. Note the number 5 sign out the right window. This is the 5,000-feet remaining sign. The white rectangular box seen out of the left window is a touchdown marker and is 1,500 feet from the end of the runway. Taxiway Echo can also be seen on the left. (Darren Large.)

EMBRAER 170, 2009 The Embraer 170 is a narrow-bodied twin jet engine aircraft that rolled off the line in 2001 and first flew in 2002. It has been used by Regional Airlines throughout the world as a short-haul carrier. During the marketing and launch of the Embraer 170, this aircraft toured the country, stopping at MMU. It was marketed as a corporate shuttle. (Peter Gilchrist.)

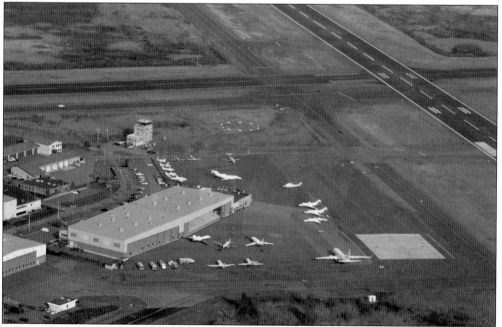

AERIAL VIEW, 2009. In the center of this photograph is the Signature Flight Support hangar. To the right is a Boeing Business Jet alongside the deicing pad. Behind Signature Flight Support is the building for DM Airports, Ltd., the management company of the airport. Runway 5-23 is on the right. (Darren Large.)

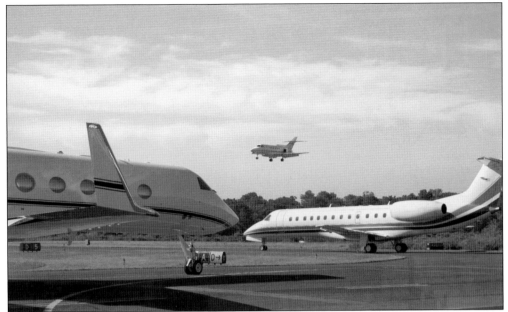

QUIETER JETS. In June 1978, the New Jersey Department of Transportation and the Division of Aeronautics conducted sound tests at the airport at the request of the Town of Morristown. The result was, "Chirping birds and traffic made more noise than many of the airplanes." Opponents, of course, were unconvinced. Other tests showed the noise came from jets headed for the metropolitan airports. (Darren Large.)

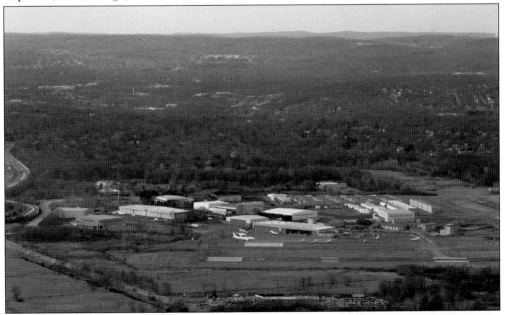

MORRISTOWN MUNICIPAL AIRPORT, 2010. On the far left, a small portion of Airport Road can be seen as it snakes through the airport and past the airport office complex. The office building sits on the approximate site of the old Normandy Water Works holding tanks. Runway 13 is in the upper right. The Columbia Turnpike is below on the left, with a small portion of the Route 24 interchange in the upper left. (Darren Large.)

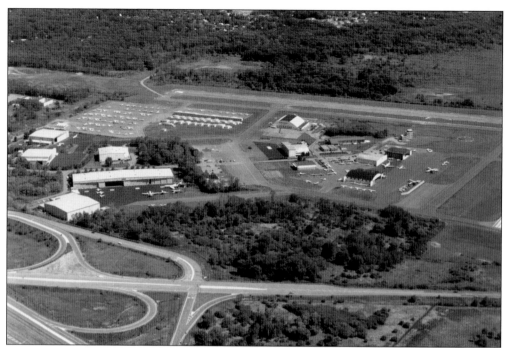

ROUTE 24 OFF RAMPS TO MMU. When the last leg of the Route 24 bypass was completed in 1992, it allowed for easy access to New York City from Morristown Airport. Prior to the 10-mile bypass, anyone landing at MMU heading east toward the city had to travel through three towns with two-lane roads and traffic lights. MMU's location next to major highways helped attract users. It is 27 miles from MMU to New York City via the Holland Tunnel. (Carl Laskiewicz.)

AIRPORT MAINTENANCE. An airport employee cuts the grass in front of the Jet Aviation hangar. Keeping the grass low prevents small wildlife from nesting near runways and taxiways. All airports are home to various birds, turtles, and wildlife that could wander into the path of an airplane taxiing or taking off. (MMU.)

WILDLIFE MANAGEMENT. Airports often attract various types of wildlife, because they are open and often lack any type of public harassment. Airport operators are forced to use harassment techniques and fencing to try and dissuade wildlife from being on the runways. Pictured is Corey Lindeman. (Darren Large.)

AIRCRAFT RESCUE FIREFIGHTING VEHICLE (ARFF). After a fatal accident on July 26, 1988, the Town of Morristown and the airport agreed to create an on-site fire company in 1994. It included a fire station and vehicle storage. It cut response time from Morristown from 6 to 15 minutes to 30 seconds. Pictured from left to right are Steve Kochik, firefighter; Art Bowles, captain; Rich VanDeursen, firefighter; Douglas Reighard, chief (in white shirt); Ed Tencza, firefighter; and Roy Kaufmann. (MMU.)

FALCON MAINTENANCE BASE. A Falcon 20 in the rear of Hangar 5 is up on jacks, and Jet Aviation personnel are performing a C check on the aircraft. The Beechcraft Baron in the foreground is getting new avionics installed and some engine work. Note the panels that have been removed for inspection work. (Jim Gieger.)

INSTALLING A DRAIN PIPE. Since the airport rests on top of a meadow, drainage has always been an issue. Much of the pipe work done recently has been to replace the 1940s-era corrugated metal pipes with cement pipe. This is an airfield project where the old corrugated pipe was replaced with cement ones. The corrugated pipe crushed down over the years and prevented good drainage. (MMU.)

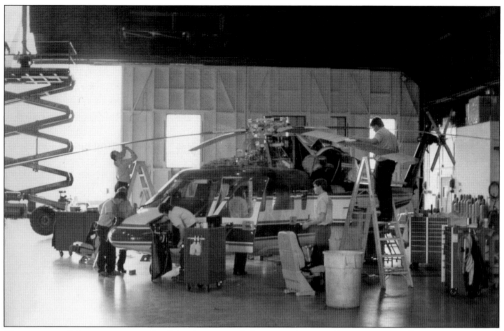

HELICOPTER MAINTENANCE. In this photograph Jet Aviation employees are conducting an annual inspection on a based tenant. Inspections are required by the FAA to be done on a yearly basis. Depending on the discrepancies found, an annual inspection can last anywhere from one week to several weeks. (Jim Gieger.)

SPIRIT OF FREEDOM, 2003. The C-54 (Douglas DC-4) *Spirit of Freedom* landed at Morristown Airport on May 2, 2003, as part of the bicentennial of aviation celebration. The *Spirit of Freedom* commemorates the 15-month effort to resupply Berlin after Soviet troops blockaded the city. The airplane later participated in a 100-airplane tribute to the Wright brothers at Kitty Hawk, North Carolina, on December 17, 2003. (Henry M. Holden.)

TAXIWAY STORAGE. Immediately after the attack on the World Trade Center on September 11, 2001, all airports in the United States were closed. Teterboro Airport, only 12 miles from New York City, was closed until security procedures were put in place to prevent unauthorized access to the field. All aircraft that could be diverted and landed were parked on the taxiway. (Darren Large.)

AVIATION EXPLORERS. Exploring is a division of the Boy Scouts of America, with the goal to introduce potential careers to boys and girls ages 14 to 21. DM Airports, Ltd., sponsors Aviation Explorer Post No. 523. The group will often host speakers and tour airport facilities as a way to learn about the many different careers in the industry. (Darren Large.)

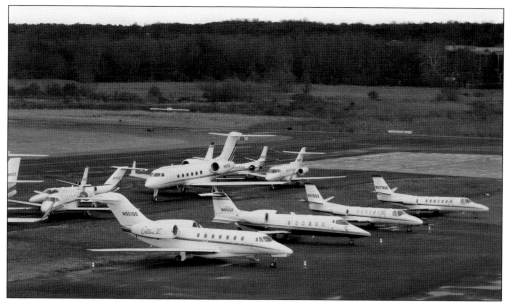

TAXIWAY STORAGE. This picture was the result of a major flooding event at Teterboro Airport. All traffic heading to the area was diverted to MMU. This picture illustrates the importance of MMU in the national airspace system. Without MMU, all this traffic would have been forced to other busier airports such as Newark, JFK, or LaGuardia. (Darren Large)

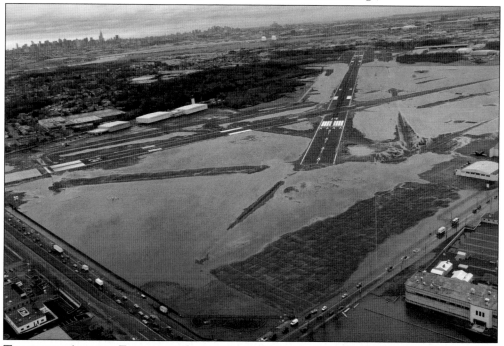

TETERBORO AIRPORT FLOODED. After a winter of heavy snows, an early spring thunderstorm caused flooding at Teterboro Airport when the snows melted. Runway 1-19 is washed out, and runway 6-24 is completely washed out in the upper right. The airport was closed to traffic, and traffic was diverted to Morristown Municipal Airport. Route 46 is in the lower left, with Industrial Avenue on the right. (NJAHOF.)

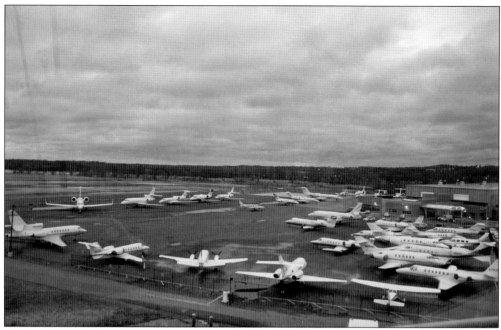

April 17, 2007. These are some of the aircraft diverted from Teterboro Airport when flooding there forced the closing of the airport. It illustrates how important both Teterboro and Morristown Airports are to the aviation industry in New Jersey. Without MMU, these aircraft would have had to be squeezed into one of the metropolitan airports such as Newark. (Darren Large.)

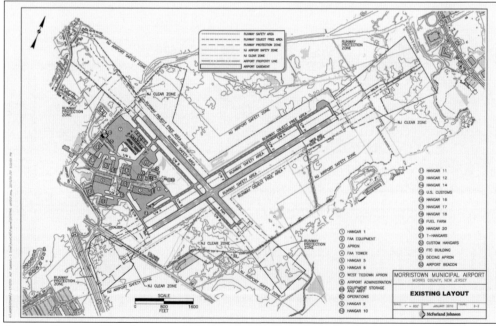

Airport Layout. This diagram of Morristown Municipal Airport in 2010 defines everything about the airport from taxiways, runway safety areas, and runway object-free areas, to safety zones. To the right facing east is Florham Park, and to the left facing north is Hanover Township. The upper left is in the direction of Morristown. (MMU.)

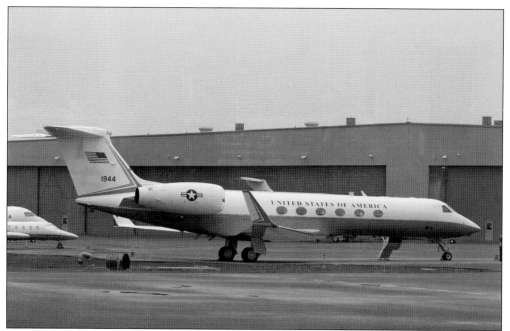

AIR FORCE GV. At any given time there are approximately 245 aircraft based at Morristown. In addition, transient aircraft from government agencies and the military also use the airport. This traffic included an estimated 16,525 visitors in 2007, and it was estimated that these visitors spent $6.89 million while in the area. (Darren Large.)

WELCOMING SIGN. Today Morristown Municipal Airport covers 638 acres, with 18 acres containing hangars and other buildings, an unspecified number of acres for runways and taxiways, and the remaining balance consisting of open space. It serves private and corporate aircraft in Morristown and Morris County. It is owned by the Town of Morristown and is operated under a 99-year lease by DM Airports, Ltd., an arrangement that began in 1982. (Darren Large.)

www.arcadiapublishing.com

MAP SEARCH

Discover books about the town where you grew up, the cities where your friends and families live, the town where your parents met, or even that retirement spot you've been dreaming about. Our Web site provides history lovers with exclusive deals, advanced notification about new titles, e-mail alerts of author events, and much more.

Find Your Place in History.

MORRISTOWN, NEW JERSEY

On July 8, 1929, a Morristown newspaper announced the opening of Morristown Airport on Bernardsville Road. The article stated the airport would be the home of the Country Aviation Club under the supervision of Clarence Chamberlin, the second man to fly across the Atlantic Ocean and the first to take along a passenger. The Great Depression halted any serious development of the airport until 1936, when there was serious talk of the land becoming an East Coast dirigible base for the *Hindenburg*. However, the destruction of the *Hindenburg* at Lakehurst, New Jersey, a year later squashed those plans. After World War II, Morristown Airport began to become a reality. General aviation found Morristown convenient and out of the traffic patterns of Newark Airport. The airport grew and prospered, and by July 1966, Morristown Municipal Airport (MMU) was called the "VIP Stop." Today, as a general aviation reliever airport, MMU accepts private, corporate, air taxi, air ambulance, training, and military aircraft and ranks 11th in general aviation operations.

Henry M. Holden is a freelance writer and the author of *Newark Airport* and *Teterboro Airport*. Darren S. Large is manager, facilities and projects at MMU and a professional photographer.

The Images of Aviation series celebrates the history of flight—from the early experimental, lighter-than-air craft to modern commercial, military, and private air machines. Using archival photographs, each title presents the distinctive stories from the past that commemorate aviation and its impact on American industries and communities. Arcadia is proud to play a part in the preservation of local heritage, making history available to all.

ARCADIA
PUBLISHING

www.arcadiapublishing.com

ISBN-13 978-0-7385-7360-1 $21.99
ISBN-10 0-7385-7360-4

52199

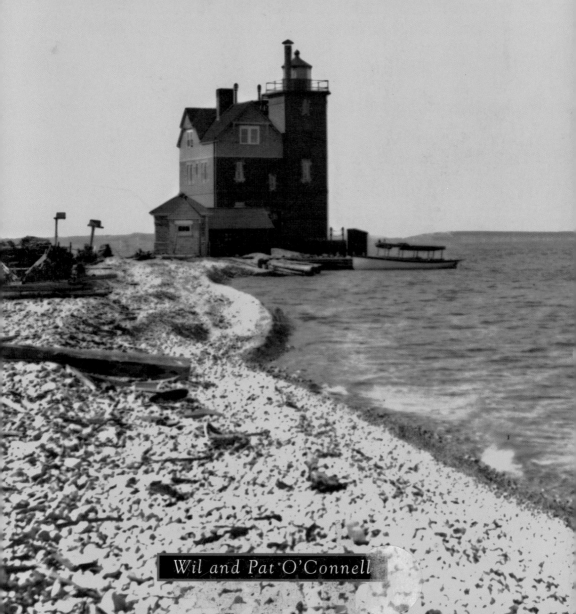

IMAGES
of America

LIGHTHOUSES OF EASTERN MICHIGAN

Wil and Pat O'Connell